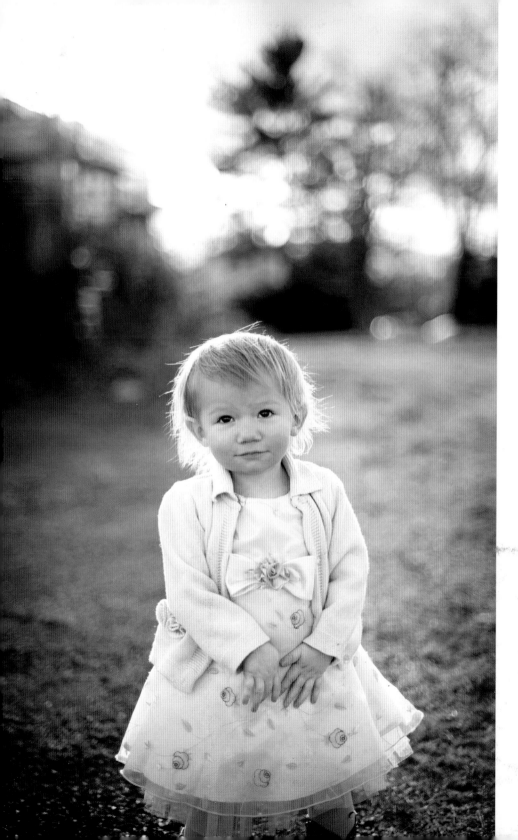

Photograph Your Kids Like a Pro

Heather Mosher

FIREFLY BOOKS

A FIREFLY BOOK

Published by Firefly Books Ltd. 2012

First printing

Publisher Cataloging-in-Publication Data (U.S.)

Photograph your kids like a pro : how to take, edit, and display the best ever photos of your kids, whatever the occasion / Heather Mosher.
[160] p. : photos. ; cm.
Includes index.
Summary: How to take, edit, and display photographs of children. Includes suggestions on how to improve snapshots, the best cameras and equipment to use; the importance of light in photographs; and suggestions on location, clothing options, props, and lighting.

ISBN-13: 978-1-77085-115-3 (pbk.)
1. Photography of children. I. Title.
779.25dc23 TR681.C5M674 2012

Library and Archives Canada Cataloguing in Publication

Mosher, Heather, 1973–
Photograph your kids like a pro : how to take, edit, and display the best ever photos of your kids, whatever the occasion / Heather Mosher.
Includes index.
ISBN 978-1-77085-115-3
1. Photography of children. I. Title.
TR681.C5M68 2012 779'.25
C2012-901756-6

Published in the United States by
Firefly Books (U.S.) Inc.
P.O. Box 1338, Ellicott Station
Buffalo, New York 14205

Published in Canada by
Firefly Books Ltd.
66 Leek Crescent
Richmond Hill, Ontario L4B 1H1

Color separation by PICA Digital Pte Ltd.,
Singapore
Printed in China by 1010 Printing
International Ltd.

Conceived, designed and produced by
Quarto Publishing Inc.
The Old Brewery, 6 Blundell Street,
London N7 9BH

QUAR.HPC

Senior editor: Katie Crous
Consultant editor: Steve Luck
Art editor: Jacqueline Palmer
Designer: Simon Brewster
Illustrator: Kong Kang Chen
Picture research: Sarah Bell
Art director: Caroline Guest
Creative director: Moira Clinch
Publisher: Paul Carslake

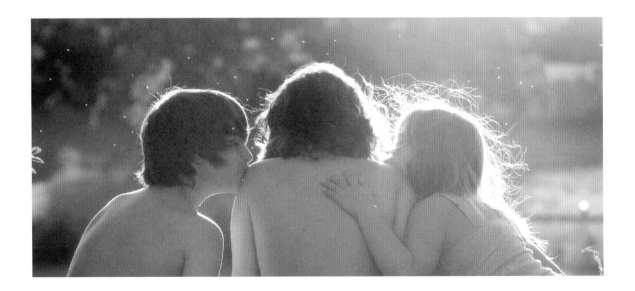

Contents

Foreword

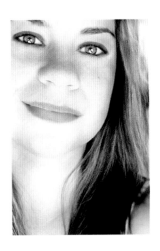

I discovered my passion for photography at an early age, with an eye for capturing the heart, as well as the beauty, of each individual. I aim to give dynamic creativity to every shoot, coining my style as everything from modern and editorial to warm and romantic. My body of work encompasses portfolios of every genre of children's photography, from maternity and newborns to toddlers and beyond.

My three children — Johnny, Michael and Kaylie (see page 4 and opposite) — are an endless source of creative inspiration. I think childhood is such a special time and, as parents, we all know how quickly it goes by. While hiring a professional photographer has its place and pretty much guarantees wonderful, treasured artistic images, having a professional by your side at every moment is clearly unrealistic, so the hope is that you will learn a few lessons from this book to improve your at-home and on-location images.

Many of my pictures are shot in and around the New York City area, because this is where I'm based, but the themes and technical aspects of my photographs can be transferred easily to your own location, wherever in the world you may be. So, read through these pages, pick up that camera and start clicking to create some beautiful memories to share for generations to come.

Heather
www.HeatherMosher.com

Nature's first green is gold,
Her hardest hue to hold.
Her early leaf's a flower;
But only so an hour.
Then leaf subsides to leaf.
So Eden sank to grief,
So dawn goes down to day.
Nothing gold can stay.

Robert Frost

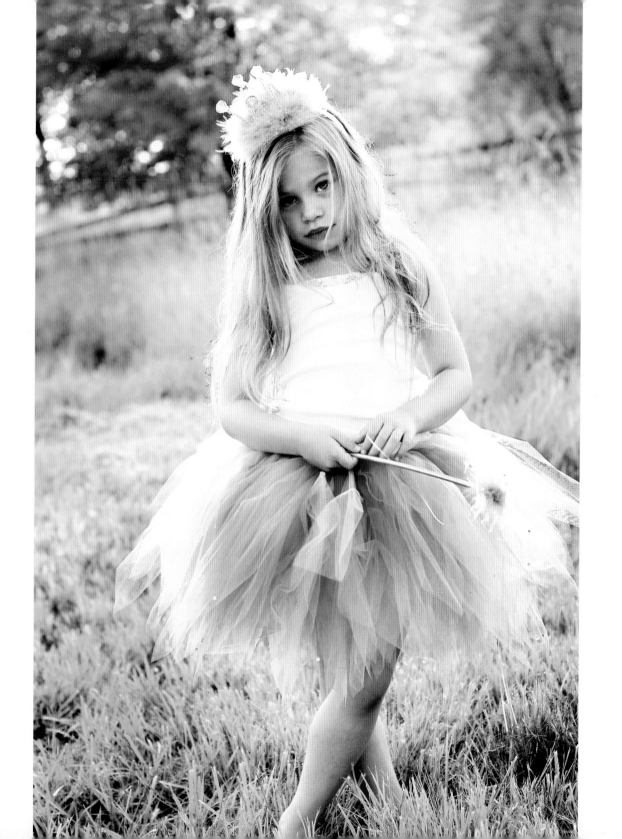

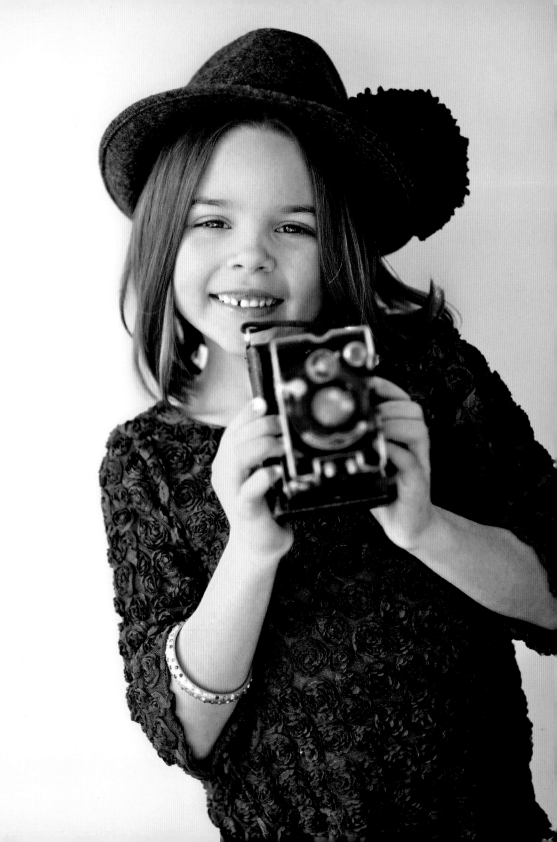

CHAPTER 1
Finding the Right Camera

Deciding on your first camera can be an overwhelming task. There is a vast array of cameras available — from inexpensive "point and shoots" to professional cameras that cost thousands of dollars, and that's before you buy a lens. And as well as cameras, there also appears to be a mind-boggling selection of accessories to choose from, making it tough to know what's essential and what's aspirational. But don't panic. In this section we'll put things into perspective and provide easy-to-follow, practical advice that will help you decide what equipment is right for you.

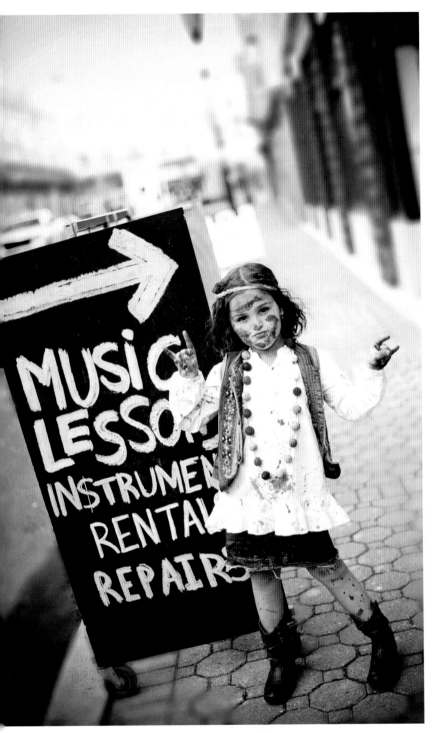

Establishing Your Needs

Choosing the right camera for your lifestyle can be as personal a choice as finding the right car. There's bound to be one that will suit you perfectly — it's just a case of finding it.

When considering your camera needs, think about what is most important to you. Do you want to just point and shoot and let the camera do the work or are you keen to have creative control? Is portability an overriding factor or are you happy to carry a camera bag with a camera and one or two extra lenses? Are you going to make large prints to put on the wall or only show images via social networks?

No One Size Fits All

Unfortunately there's no perfect all-around camera that can produce professional-looking poster-sized prints automatically of any subject at any distance and fits neatly in your pocket. There's a trade-off with all cameras. What's important is that you're clear in your own mind about what you want from a camera before making a purchase.

If you want to display large canvas prints, perhaps with attractively blurred backgrounds, then image quality and manual control are going to be primary considerations. In this case a compact point and shoot is unlikely to fit the bill. If, however, your aim is to record your baby's first years to post to websites so that friends and family around the world can see your snaps, then buying an expensive digital single-lens reflex (SLR) camera and lenses is simply a waste of money.

In the next section, So What's Really Out There?, we'll look at the most popular types of cameras and their advantages and disadvantages. But for now, decide what you want out of your camera. Ask yourself the sorts of questions posed above. This will make choosing your camera an easier process.

Sensors and Megapixels: Debunking the Myth

There's a lot of confusion surrounding sensors and the significance of megapixels (MP). The sensor is the part of the camera that records the light from the scene you're photographing. It's made up of millions of individual photo sensors, or "photosites," each one representing one pixel (short for picture element) of a digital image. A sensor with, for example, 10 million photosites is said to have 10 megapixels (mega = million).

Megapixel count has been used by the camera industry as a way of marketing cameras, and there is a huge misconception that the more megapixels a camera has, the clearer the images it produces. This common myth is simply not true. In terms of print size, a 5-MP camera is capable of producing photo-quality letter-sized prints, while a 10-MP camera can print up to tabloid (11 × 17 inches/28 × 43 cm) format quite happily — more than sufficient for most of us. So what's the reasoning behind professional cameras of 20 to 30+ megapixels? Well, most professional photographers need equipment capable of printing large-format sizes (sometimes as large as billboards) for advertising purposes or for high-definition studio work for glossy magazine prints.

More important than megapixels is sensor size. Sensors range in size from those that are no bigger than the nail on your pinkie (as used in camera phones and compact cameras) to those used in professional digital SLRs, which are around 36 × 24 mm (1$^{1}/_{2}$ × 1 inches). Generally, the larger the sensor the better the images. This is because the individual photosites are larger and therefore better at collecting light. The more efficient the sensor is at capturing light, the clearer the image will be. This is most noticeable in poor light conditions, where small sensors struggle to capture clean images. Another advantage of larger sensors is that they make it easier to deliberately blur parts of your image for that creative, professional look (see Selective Focus, pages 62–63).

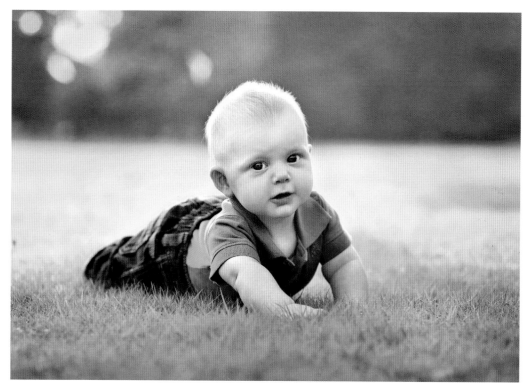

BLURRED BACKGROUND
Opposite: To get that professional, blurred-background look, ideally you need a camera with a good level of manual control. Digital SLRs and "bridge" cameras allow you to choose your own shutter speeds and aperture settings — essential if you want to capture images that stand out.

AT EASE!
Over time you should feel totally relaxed and comfortable with your camera and all its controls, and then you'll be happy to experiment with different settings and try out different shooting angles, like this ground-level shot. (Photo: Aneta & Tom Gancarz)

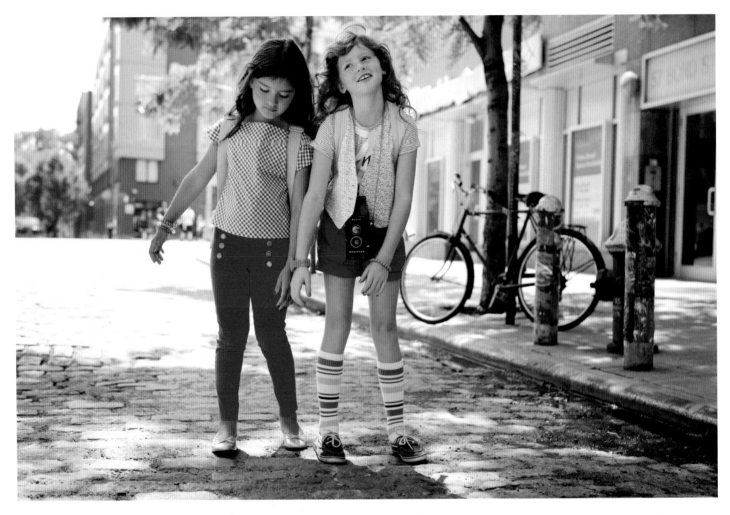

A CAMERA TO SUIT
Whatever your current skill level and future aspirations, there is a camera out there for you, but it's important that you know all the options before choosing. (Photo: Allison Cottrill)

So What's Really Out There?

Having identified what you want from your camera, the next step is determining what sort of camera fits your needs.

It's possible to categorize cameras in numerous ways, but here we're going to sort them into three groups based on user experience — beginner, intermediate and advanced.

Beginner

If you have little or no experience with photography, start with a camera that has full "auto" settings, including autofocus. All point-and-shoot cameras are fully automatic, and if all you want are snapshots to show friends and family either online or as small prints, then such cameras are an inexpensive option. Many models are wi-fi enabled for instant email sharing and many are thin enough to tote around in a pocket or purse. The drawback with most point-and-shoot compacts is the small sensor size (see page 11). However, you don't have to restrict yourself to a small-sensor compact to have full auto settings. There are a number of different types of cameras with larger sensors that also offer fully automatic shooting. There are the so-called large-sensor compacts. These feature larger-than-normal sensors (with improved image quality) in a compact (but not ultra-small) body, and many offer some form of zoom function. Alternatively, take a look at one of the "bridge" cameras. These look like SLRs, but the zoom lenses are not interchangeable. While both types of cameras can be used like a point and shoot with full auto settings, most offer some form of manual control should you want to start experimenting with manual settings.

Intermediate

If you've owned a compact and are looking for something that offers improved image quality and a greater level of control, including interchangeable lenses for more varied wide-angle or telephoto shooting options, consider either a mirrorless rangefinder-style, micro four-thirds camera or an entry-level, or "prosumer," digital SLR. Mirrorless interchangeable-lens cameras offer a balance between portability, image quality and creative control. All feature a rear LCD screen that can be used to compose images, but some also have an electronic viewfinder, which can make it easier to see the subject in very bright conditions.

Prosumer digital SLRs are like professional SLRs in that they have an optical viewfinder that has a mirror. When the shutter release is pressed the mirror flips up, allowing the light to pass directly to the sensor, where the image is captured. Optical viewfinders are brighter and more responsive than electronic viewfinders.

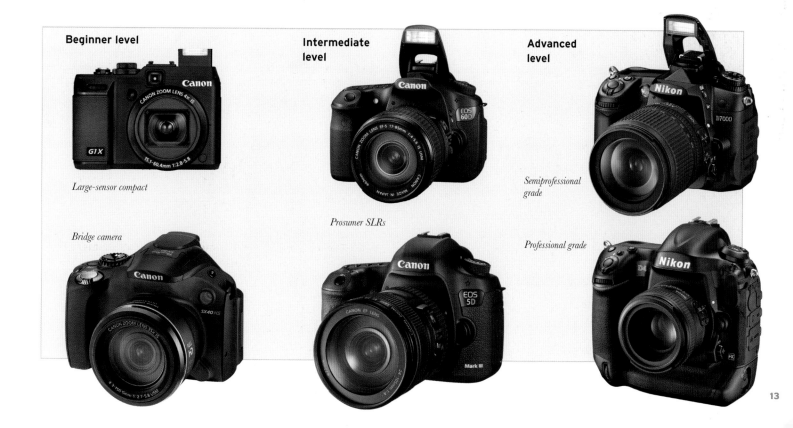

Beginner level

Large-sensor compact

Bridge camera

Intermediate level

Prosumer SLRs

Advanced level

Semiprofessional grade

Professional grade

Prosumer digital SLRs have sensors comparable in size to many professional digital SLRs and offer excellent image quality. Their controls are readily accessible, making it easier to set up more creative shots. But the cost of accessible controls and larger image sensors is a bulkier and heavier body.

With all the same manual settings found on professional gear, these cameras also have shooting modes and set scenes, such as night, landscape and sports, for when you want the camera to take over. Such cameras are great for someone who wants to learn the fundamentals and technical aspects of photography, while still enjoying the ease of automatic settings to fall back on if things aren't going right.

Advanced

The last type of camera is the professional grade. In many respects there are often few differences between professional and prosumer digital SLRs. Professional cameras tend to have better weather sealing, more rugged bodies and perhaps a more sophisticated focusing system. But in the right hands and with the same lenses, you'd be hard pressed to tell the difference between an image taken with a pro camera and one taken with a prosumer model.

Where pro cameras do differ is that they don't have any automatic or scene settings built in. So you need to know your photography fundamentals if you're considering a pro SLR; otherwise, trying to capture that priceless first step onto the school bus will most likely leave you with a blurred image and a missed opportunity.

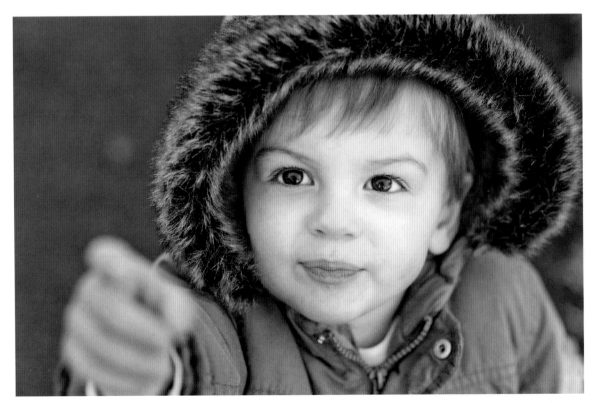

I WANNA SEE!
Your children are bound to want to handle the camera whenever you take their picture, even if it's just to see the preview screen on the back. With sticky little hands around, you may want to think about getting a camera that's sturdy and shock-resistant. (Photo: Aneta & Tom Gancarz)

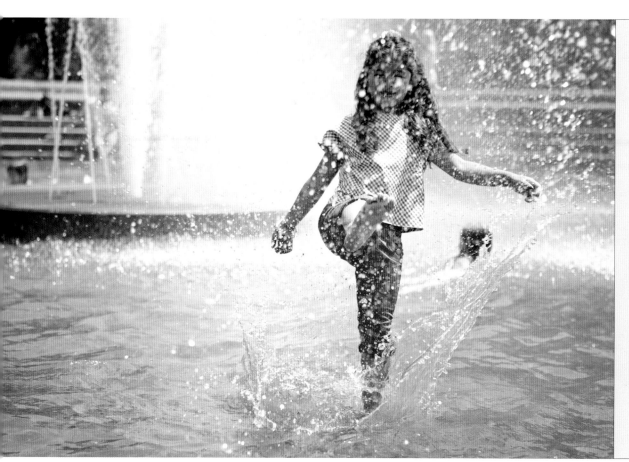

SHOOTING BASICS
If it's all too confusing at this stage, and you're none the wiser as to which settings you'd want to control and why, turn to pages 22–29 for a complete rundown on exposure, aperture and focus.

WET AND WILD
If your family activities involve a lot of water — playing on the beach or in or around the pool — then a waterproof or at least a water-resistant camera may be a wise choice. Read reviews and check online forums to see if your prospective camera is well sealed. (Photo: Allison Cottrill)

FAMILY-FRIENDLY FEATURES

Today's cameras have many beneficial features for moms and dads on the go. Consider whether the following would be useful:

- Stability features, such as a metal body and shock-resistance settings, will ensure your camera's longevity and help protect it from rough treatment by little hands.

- In-camera editing will help you edit as you go, or whenever you have a spare minute.

- Waterproofing is a great function for vacation snaps on the beach and in the pool or for those "playing around in the water" moments.

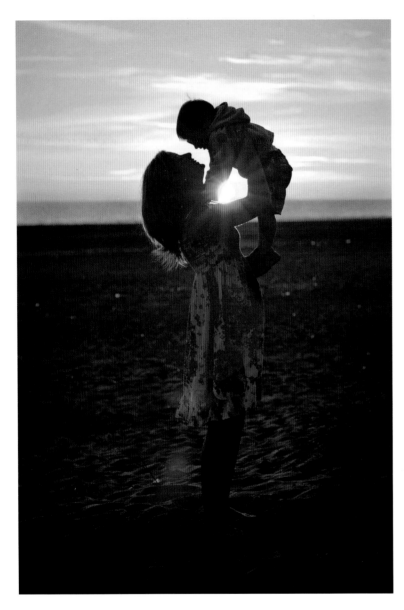

PURE GOLD
Capturing sunset photos like this one is harder than simply pointing and shooting. To make the most of all the magnificent moments you're going to share with your family, learn about your camera and its settings. (Photo: Aneta & Tom Gancarz)

Understanding the Camera

Planning your sessions and clothing options can be one of the most enjoyable aspects of photography, but all of the fun stuff means very little if you don't understand how to use your camera to the best of its abilities.

Having identified what you want from your camera and having narrowed down your camera selection, you should ask around and do some final research before making your purchase. You may have friends or family members who are keen photographers. Ask them for advice, and see if you can try their cameras.

There are also a vast number of magazines and websites that provide excellent independent advice. Whenever I purchase any new equipment, I spend weeks pouring over online reviews and comparison sites to make sure I am as well-informed as possible before making a large investment. This homework makes me more confident in my purchase and reassures me that I'm making the right decision.

Go for a Test Drive

This purchase is an investment, so don't be shy in devoting your time to discovering the best fit. Try to handle the different cameras on your wish list, and take as many sample shots as possible to see if it's right for you. Ask yourself these questions:

- Is the camera comfortable to hold?
- Is it easy to see the subject? Do you need a viewfinder or can you use the rear screen?
- Does the camera focus quickly in good light?
- Are the controls easy to reach? Or do you have to press lots of buttons to get to the controls you want to adjust?

Purchasing a camera that is too difficult to manage for everyday use or too complicated to allow you to figure out basic settings can end up being a costly mistake. Instead, stick to the "less is more" philosophy and use a camera that you can quickly grab when the moment to snap strikes you. However, you should be prepared to learn a little about the language of photography if you want to shoot professional-

looking images — so think about a camera that you can "grow" into as you become more experienced.

Learn About the Camera

After you've done your research, you'll have a good idea as to the camera you want. When with the salesperson, make sure he or she takes the time to go over all the features and settings so you have a clear understanding of how each feature works. Once you have taken your purchase home, the next step is to read the manual. As daunting a task as it may be, the owner's manual will show you how to make the most of your camera in a variety of shooting scenarios, from shooting fast-moving action, through daylight and nighttime portraits, to landscapes.

It's vital that you spend time learning how to use all the functions and settings on your camera. Not only will this ensure that you're making the most of your camera and achieving optimum image quality under varying shooting and lighting conditions, but it's also vital if you're keen to take more creative and professional-looking images. By all means leave the camera on its auto setting initially, while you're getting used to handling and shooting with it, but

don't be afraid to start using some of the semi-manual settings, such as aperture and shutter priority. Being able to control the aperture is essential if you want to use selective focus (see pages 62–63), while controlling the shutter speed allows you to experiment with creative blur — just two commonly used photo techniques.

Examine Some Test Shots

Take a number of images and either download them to your computer or print them out directly from the camera. Look at the results carefully to make sure you're happy with the quality. Check that the images don't appear too dark or too bright, that the colors look bright and accurate, and that everything you want to be in focus is sharp.

Once you have become familiar with your camera's functions, both inside and out, you are free to let your creative side take over and put your hard work to good use.

Accessories, Accessories

What savvy mom or dad doesn't love to accessorize their new toys! It's possible to spend hundreds of dollars on add-ons for your camera, but here are some essentials.

The first thing you'll want to do with your new addition is protect it with a suitable camera bag, which will vary depending on the level of camera you have chosen. If you have bought a point-and-shoot model, a small, stylish case with enough padding to protect it is a must. For those with larger prosumer cameras (and especially if you're considering buying an additional lens or two), you will need an actual camera bag. These are designed with sturdy, padded, built-in walls to protect your camera and lenses from unforeseen bumps and shifting. Extra pockets for memory cards and lens wipes are also built in.

While the bag I use is not exactly the most stylish bag on the market, it does its job well and protects my investment. The camera bodies are thoroughly protected by thick padded walls, as well as a sturdy Velcro seal and latch lock to keep my gear from spilling out. But most importantly, my gear is always completely protected. For a parent on the go, it's possible to buy bags that double-up as travel bags, or even as a diaper bag, still with room to hold up to a 17-inch (43-cm) laptop and your camera gear.

Memory Cards and Batteries

Once bitten by the photography bug you may find yourself taking hundreds of shots a week, or even more. In this case, other essential items to buy are memory cards and a spare battery. Memory cards are much less expensive than they used to be, so it's worth splurging on a couple of 8 GB or even 16 GB cards. These won't break the bank, and you'll never find yourself having to delete images to make room for new ones when out shooting. Also, now that cameras shoot high-definition video, you'll appreciate the extra capacity if you suddenly see a good family movie opportunity.

CARRYING YOUR GEAR
An easy-to-carry, well-stocked bag will help you become a photographer — and parent — on the move, always ready to capture that special moment. (Photo: Allison Cottrill)

A spare battery is also essential. There's nothing worse than going out on location with your camera only to have your battery die after 5 minutes of shooting. With a spare you can always ensure that you have a fully charged battery with you at all times.

Flash

Although most cameras have a built-in, pop-up flash that can provide some light in dark conditions, these units are small, underpowered and usually produce harsh, flat, unattractive lighting. Although not an essential purchase right away, sooner or later you should consider buying an external flashgun that you can attach to the hot shoe connector on top of the camera. These are much more powerful and versatile than the built-in version and will produce softer, more natural results when you need to throw a little more light onto your subject's face.

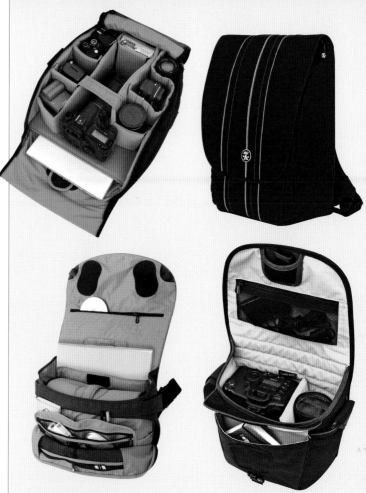

IT'S IN THE BAG

For many, photography can become an overriding passion, and over time you may find yourself adding lenses, filters and other equipment to your basic digital SLR setup. In which case, a purpose-built camera bag is the best way to keep your expensive equipment safe and secure. Camera bags have come a long way since the days of ugly, boxy-looking cases; today you can buy any number of stylish bags that, from the outside, don't even resemble a camera bag.

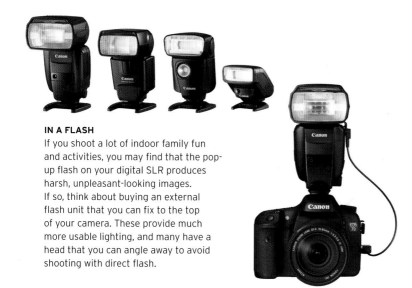

IN A FLASH

If you shoot a lot of indoor family fun and activities, you may find that the pop-up flash on your digital SLR produces harsh, unpleasant-looking images. If so, think about buying an external flash unit that you can fix to the top of your camera. These provide much more usable lighting, and many have a head that you can angle away to avoid shooting with direct flash.

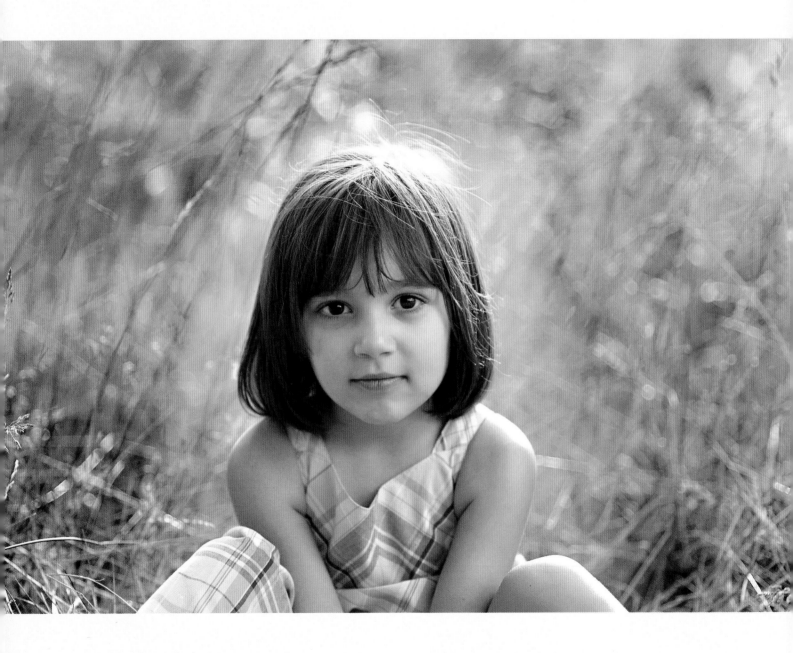

CHAPTER 2

Seeing the Light

The word "photography" is derived from the Greek for light, *photos*, and for drawing, *graphé* — literally, "drawing with light."

Just as a painter uses paint as a medium for creating art, a photographer uses light. To really understand how photography works and how timeless images are created, you must first understand how cameras deal with lighting and the various options that are available to you through a camera's settings. We cover this in Shooting Basics, pages 22–29, which guides you through exposure, aperture and depth of field. Then you'll need an insight into the important concepts behind light. For the budding photographer, taking time to study the light around you will help to lift your images from family snaps to professional-looking photo portraits.

Shooting Basics

It's very easy to set your camera to auto and fire away, safe in the knowledge that it's going to make all the decisions for you. You're likely to end up with accurately exposed images most of the time, but you're really missing out on getting creative with your camera.

If you want to take creative, professional-looking photos, it's important that you have a clear understanding of exposure and all the elements that relate to it: aperture, shutter speed, depth of field, ISO and shutter priority. You may be familiar with these terms but felt too intimidated by technology to really get to grips with them. In reality, they are straightforward concepts that will take your photography to another level.

What Is Exposure?

When we take a photo, the camera's sensor (or film) is exposed to light, hence the term "exposure." Importantly, every exposure is governed by two factors — the amount of light that reaches the sensor and the length of time the sensor is exposed to the light. Together these factors create the exposure setting. There is a third factor that involves the sensitivity of the sensor to light, but for the time being we'll stick with the first two.

IN CONTROL
On one level, exposure is all about making sure that your images aren't too bright (overexposed) or too dark (underexposed), but this is only one side of the story. The controls that you can use to set exposure also affect your images in other ways. (Photo: Helen Rae)

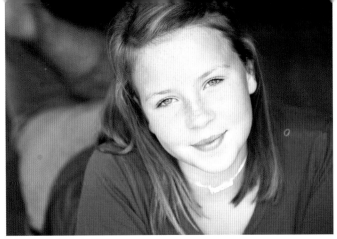

Overexposed

The face is flooded with white light, which results in a loss of definition and detail.

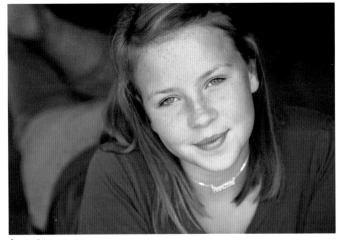

Correct exposure

Skin tone is properly represented and all the freckles are visible.

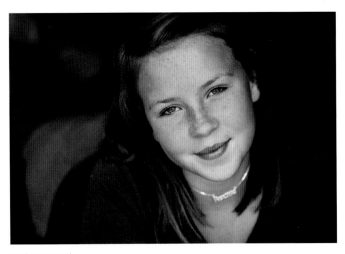

Underexposed

The background loses color and becomes a black area, into which the hair and shoulder disappear.

Aperture

Most camera lenses have a delicate mechanism that forms a hole (the aperture) through which light passes before traveling on to the sensor. The aperture is adjustable in size, and determines the amount of light that reaches the sensor. In bright conditions the aperture is narrow in order to prevent too much light from hitting the sensor, while in dark conditions the aperture is wide open to allow in as much light as possible. However, as we shall go on to see, the aperture does much more than govern the amount of light reaching the sensor: in fact, it is the key control to making great-looking photos.

Shutter Speed

So if the aperture manages how much light reaches the sensor during an exposure, what determines the length of time for which the sensor is exposed? As well as the aperture, all except the most basic point-and-shoot cameras also feature a shutter, a mechanism that slides rapidly back and forth, exposing the sensor to the light as it does so. As with the aperture, the speed of the shutter is variable, from a fraction of a second to 30 seconds or more. Unsurprisingly, in bright conditions the shutter speed is fast, perhaps as fast as 1/2000 second, while in murkier light the speed will be much slower to ensure sufficient light reaches the sensor.

It Takes Two

A photo's exposure, therefore, is essentially a combination of the aperture and shutter speed settings. When taking a photo the aim is to use an aperture and shutter speed combination that results in an image that is accurately exposed — one that's not too bright (overexposed) or too dark (underexposed).

To help achieve this your camera has a built-in light meter that measures the light entering the camera. When in auto the camera uses this information to set a correct aperture and shutter speed combination, but if you leave it up to the camera to decide, you're relinquishing control over settings that can dramatically alter the appearance of your image.

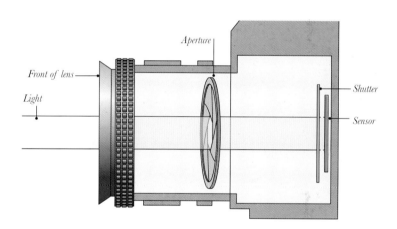

THE JOURNEY OF LIGHT
When you take a photo, light from the scene you're photographing is focused by the lens, before it is regulated by the aperture. It then travels on through the open shutter to the sensor beyond. The aperture and shutter speed together determine the exposure.

Aperture and Depth of Field

When you look through a collection of professionally shot photos, it's likely that a large proportion of them show an attractive, out-of-focus background, or perhaps some other part of the image that is deliberately blurred. We will look at this effect in Chapter 3, in the section on Selective Focus (see pages 62–63), but here we're going to show how it relates to exposure and aperture.

Out-of-focus effects are determined by depth of field — the area of the image that appears sharp. If an image is in focus from foreground to background, it's said to have a wide depth of field; if, however, only a small part of the image is in focus, it's said to have a narrow or shallow depth of field, or shallow focus. The reason this is relevant to our discussion here is that depth of field is determined by the aperture setting. A wide aperture setting creates a narrow depth of field, while a narrow aperture setting creates a wide depth of field. So, if you use a wide aperture setting and focus on your child's face, it's likely that the background will be nicely blurred. However, adjust the aperture to a narrow setting and more of the scene will be in focus.

Aperture Settings

So far, so good. So what exactly is a wide aperture setting, or a narrow one, for that matter? Aperture settings are measured in *f*-stops or *f*-numbers ("*f*" refers to the focal length of the lens). What's slightly confusing is that the smaller the *f*-number the wider the aperture. So an aperture of *f*/2 or *f*/4, for example (you can see the setting when you look through the viewfinder), is actually about as wide as many lenses can go, while an aperture of around *f*/16 or *f*/22 is the smallest size. So, for a narrow depth of field (shallow focus) use an aperture setting of around *f*/4 or less, and for a wide depth of field (everything in focus) use an aperture setting of around *f*/16 or more.

Armed with this knowledge you can see just how important it is to take manual control of the aperture setting. If you leave the camera in auto it's likely to set an average aperture setting depending on the lighting conditions, which may or may not set the depth of field you want. It may, for example, set an aperture of *f*/8 when, under your control, you could easily set a pleasing background-blurring *f*/4 or *f*/2.

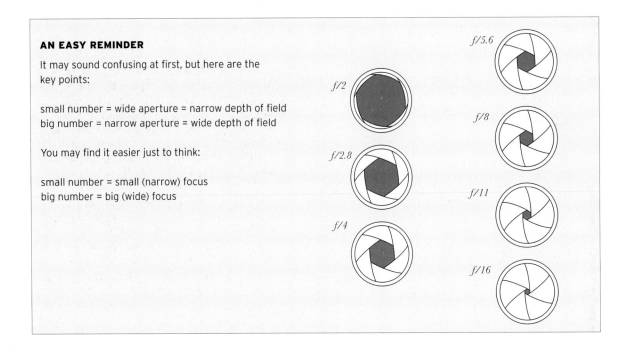

AN EASY REMINDER

It may sound confusing at first, but here are the key points:

small number = wide aperture = narrow depth of field
big number = narrow aperture = wide depth of field

You may find it easier just to think:

small number = small (narrow) focus
big number = big (wide) focus

f/2 *f*/2.8 *f*/4 *f*/5.6 *f*/8 *f*/11 *f*/16

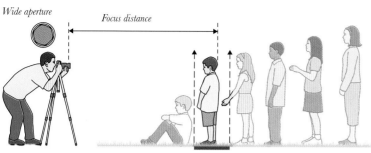

Wide aperture

Focus distance

Depth of field

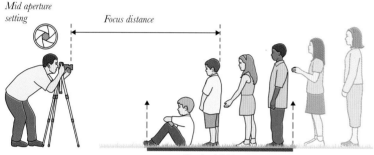

Mid aperture setting

Focus distance

Depth of field

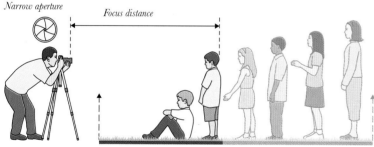

Narrow aperture

Focus distance

Depth of field

USING APERTURE TO VARY FOCUS
This diagram shows how using a narrow aperture setting (f/22) ensures that almost everything in front of the camera is in focus, while using a wide aperture (f/2) results in only a narrow part of the scene being in sharp focus.

Aperture Priority

The best way to take manual control of the aperture setting is to use the camera's aperture priority shooting mode. This is usually represented by an "A" or "Av" on the mode dial or menu. In this mode you can set the aperture and the camera will automatically select a shutter speed that's appropriate for the amount of light present in the scene. This is a perfect balance between full auto and full manual control. You can determine the depth of field you want, but the camera will help to make sure the image is accurately exposed. But remember, because overall exposure is governed by a combination of aperture setting and shutter speed, if you adjust one it will impact on the other. It's logical if you think about it — if you reduce the amount of light entering the camera through a narrower aperture setting, you have to increase the amount of time the sensor is exposed to maintain the same overall exposure.

KNOW YOUR DIAL
If you're using a bridge SLR-type camera, a high-end compact, or an SLR, the camera will feature some form of shooting mode dial, similar to the one shown here. Naturally, each dial will vary from camera to camera, but what they will all have in common is an aperture priority setting (usually "A" or "Av") and a shutter priority option ("S" or "Tv"). Learn how to use these settings and you'll begin to appreciate how much more creative you can be as a photographer.

F-stops and Shutter Speed

There is a direct relationship between *f*-stop and shutter speed. Look back at the diagram showing aperture sizes on page 24. Each setting — *f*/16, *f*/11, *f*/8, *f*/5.6, *f*/4 and so on — is twice as big as the previous one. In other words, *f*/4 lets in twice as much light as *f*/5.6. Now look back at the box on shutter speeds on page 23: each one is half or twice as long as its neighbor. This is deliberate. For example, when in aperture priority mode, let's say you set an aperture of *f*/4 and the camera automatically sets a shutter speed of 1/250 second to get an accurate exposure based on the available light; if you then increased the aperture setting to *f*/2.8 (twice as wide as *f*/4) the camera will halve the shutter speed to 1/500 second to maintain the correct exposure. Increase the aperture again to *f*/2, and the shutter speed would need to halve again to 1/1000 second.

This is important, because in really bright conditions you may not be able to take a good photo with the aperture wide open since the camera won't be able to set a shutter speed that's fast enough to prevent the image from overexposing. Life isn't always perfect for photographers!

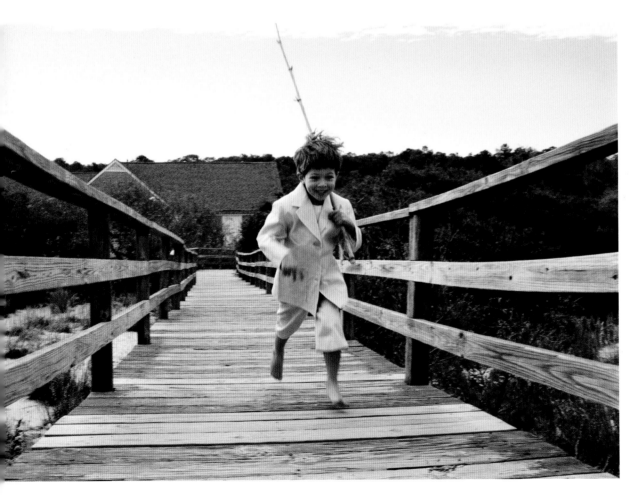

WIDE DEPTH OF FIELD
This wonderful image lends itself to a wide depth of field — in this case an aperture of f/16 was used. This helps to keep the entire length of the wooden jetty in focus, which in turn leads the viewer's eye into the image. (Photo: Mariacristina Vimercati)

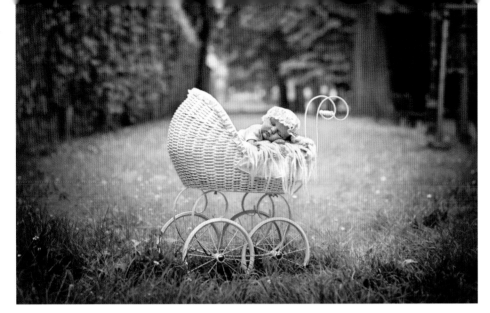

SHALLOW DEPTH OF FIELD
The serene, gentle nature of this image is helped by a shallow depth of field, which throws the background out of focus, ensuring our attention remains focused on the antique baby carriage and its gorgeous, sleepy occupant. (Photo: Aneta & Tom Gancarz)

Shallow depth of field: A wide aperture stylishly blurs the background, leaving the subject as the main focus.

Medium depth of field: The background starts to blur but is still easily decipherable.

Wide depth of field: A narrow aperture setting keeps the background in focus.

PUT IT INTO PRACTICE

When you're next out with your camera, set the shooting mode dial to aperture priority (check your manual if you're not sure how to do this) and, using a doll or teddy bear, zoom in so that the body fills the viewfinder but making sure you can still see the background behind. Take several shots at various aperture settings, starting from the widest (the smallest number) to the narrowest (the biggest number). When you come to review your photos, you'll see how the background starts off out of focus but gradually becomes sharper as you set a narrower aperture.

You'll find it easier to perform this exercise during a bright, sunny day, since when there's lots of light around you can use the narrowest aperture and still get a reasonably fast shutter speed. As a very general rule of thumb, avoid using shutter speeds of less than around 1/30 second. At these relatively slows speeds you may find that your images begin to look blurred. If necessary, increase the aperture setting until you get to speeds of around 1/60 second or 1/125 second. (Photos: Steve Luck)

ISO: The Third Factor

I mentioned earlier that there was a third factor that determined exposure, so let's cover this now. All cameras have what's called an ISO setting control. Look in your camera's manual to find out how to adjust it. This control allows you to increase the sensor's sensitivity to light. Most cameras will have ISO settings of 100, 200, 400, 800, 1600, 3200 and maybe more. Don't worry too much about the numbers, just know that with each higher setting you're making the sensor twice as sensitive to light as the previous setting. This is useful when light levels start to fall, because you can increase the ISO setting and maintain the same shutter speed and aperture combination.

For example, let's say you want to use an exposure of $f/16$ at 1/60 second at the standard ISO 100 setting. However, a cloud passes overhead and you notice that the camera has set a slower shutter speed of 1/50 second. At this shutter speed, children's movements may become blurred and you may not be able to hold the camera still when taking the photo (also resulting in a blurred image). Don't panic though; reach for the ISO control and increase the ISO setting from 100 to 200. This makes the sensor twice as sensitive (in effect reducing the amount of light needed for a correct exposure), and the camera will set the original shutter speed of 1/60 second — a safer shutter speed. Increase the ISO setting still further to 400, and the shutter speed will change to 1/125 second. So, you might ask, why don't we just leave the camera on the highest ISO setting to always give us fast shutter speeds? Well, the answer is "noise." You may have noticed that some photos have ugly, discolored blotches in them, which are most apparent in shadow areas — this is known as noise. The higher the ISO setting, the higher the risk of introducing noise into your images. Some cameras cope with noise better than others. The worst offenders are small point-and-shoot cameras, which can exhibit noise at relatively low ISO settings, while professional digital SLRs can be noise-free with ISO settings as high as 800 or even 1600. Make your own tests to see at what ISO setting you think noise becomes an issue with your camera.

So by all means use the ISO setting to help when light levels drop and you want to maintain a particular exposure setting, but be wary of the dreaded noise, since this can ruin your photos.

Get Shooting

Now that you have a basic knowledge of exposure, and how aperture and shutter speed settings can alter your images, go out and test the theories for yourself. Don't worry about making mistakes — you're bound to end up with images that don't work for some reason or another. The important thing is to familiarize yourself with your camera's exposure controls so that you can learn how to take creative, professional-looking photos.

THE NOISE EFFECT
The photographer of this snapshot would have fared better if he had used the flash or kept his ISO at a rate high enough to allow him to keep his shutter speed at a handheld level. As it is, the image appears unsharp and grainy.

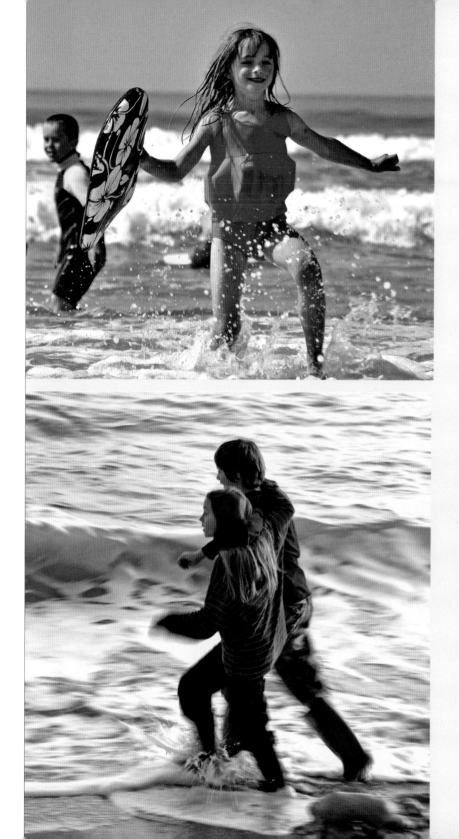

SHUTTER PRIORITY

Alongside the aperture priority setting on the shooting mode dial, you'll also find the shutter priority option (usually denoted by "S" or "Tv"). In this mode you set the shutter speed and the camera will set an appropriate aperture setting for the available light. Use this setting if freezing movement is more important than setting depth of field. For example, if the birthday girl is about to whack a piñata, you'll want to make sure the shutter speed is fast enough (say 1/250 second) to freeze the action.

But also think about being creative with blur. The next time you're out and about with your children, get them to run around and photograph them at different shutter speeds using shutter priority mode. At certain speeds (around 1/30 second) you may be able to capture them so that their top halves are still while their legs are a blur of motion — it's a great effect!

FAST SHUTTER

This image of a little girl emerging from the surf was shot using a shutter speed of 1/400 second. This is fast enough to freeze her movement and to capture the droplets of water in mid-flight. (Photo: Steve Luck)

SLOW SHUTTER

Don't always aim to freeze motion with a fast shutter speed, because sometimes it can make a scene that has movement appear static and uninteresting. These two youngsters were strolling along the beach, and although their heads are still, the slow shutter speed of 1/25 second gives their legs, arms and the splash of water some pleasing movement. (Photo: Steve Luck)

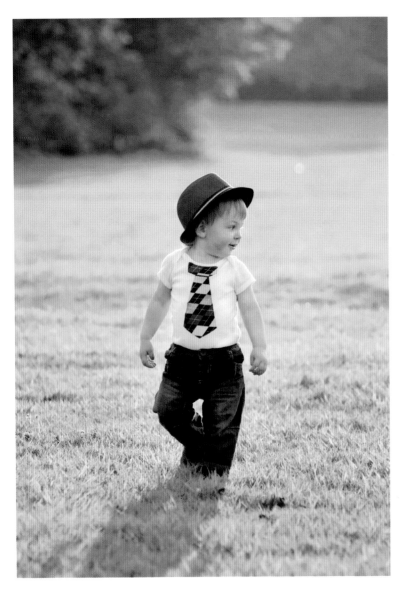

How Light Works With a Photo

No matter what equipment you're using or how fantastic the location, without the right light your image may still appear to others as a poorly timed snapshot.

If you're a beginner and using your camera in automatic mode, you're essentially letting the camera determine how much light reaches the sensor. All modern cameras have a built-in light meter that measures the available light. Having assessed the light level, the camera then automatically sets an exposure setting appropriate for the amount of light it detects. This is a great feature for those who are unsure of how to set exposure using one of the semi-manual or manual settings, and there is no shame in relying on your equipment to do some of the heavy lifting from time to time.

Taking Control

However, if you're more technically advanced, you may be choosing your own shutter speed and/or aperture — which together set the exposure, as we've seen in Shooting Basics, pages 22–29. Naturally, in most cases you want to set an exposure in which everything, but most importantly your subject, is brightly (but not too brightly) lit.

But this is only one aspect of how light and photography work together. Whether you choose the settings yourself or rely on the camera's automatic feature, all you are doing is controlling the quantity of light reaching the sensor. It does not determine the quality of light — whether warm and soft, or bright and harsh. Indeed, it is the quality of light, and not just the quantity, that can make or break an image, and that is what makes the subject of lighting so fascinating, and achieving good lighting so elusive.

THE MAGIC INGREDIENT
The quality of natural light affects how your outdoor images look. This image was taken in late afternoon, toward the end of a summer's day. The quality of the light is soft and diffuse, and filled with a warm glow that you can almost feel on your skin. (Photo: Aneta & Tom Gancarz)

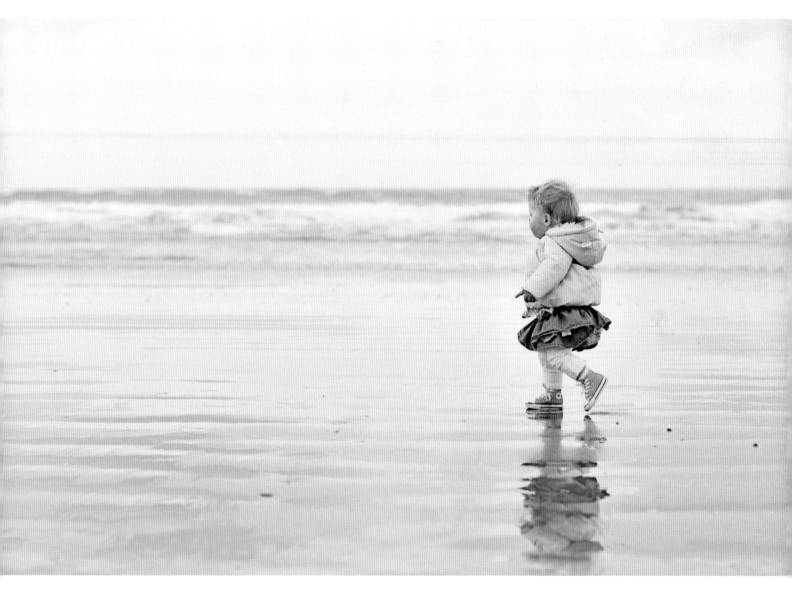

MAKING THE MOST OF IT

Like life, light isn't always rose-tinted — how dull it would be if it were! As a photographer you often have to use the light you have, and a slightly overcast day creates hazy, shadow-free light that can give an image an elegant simplicity, as here, where the light complements the simple backdrop of this wonderfully composed portrait. (Photo: Jess Morgan)

Getting Acquainted with Light

To really understand how light works, both in terms of quantity and quality, you need to experiment with it. Feel free to have fun and make mistakes along the way. You may end up loving some of your results but hating others. Learning how to make an image look more gentle by bringing in a little too much light, or how to create a silhouette by exposing for the background rather than lighting your subject, are just some examples of the different effects you can achieve by experimenting with the light around you.

The most common mistake I see parents making with light is shooting in full sunlight. The misconception is that the more light there is, the more visible their children's faces will be. But even if you have just a little experience with photography, you'll quickly learn this isn't the case. Shooting in sunshine at noon when the light is bright and harsh more often than not results in washed-out features and squinting eyes — which may not produce the type of portrait you want.

LOOK INTO THE LIGHT
You should usually avoid taking portraits in direct bright sunshine, particularly if it's shining in your subjects' faces, because they're bound to end up squinting. Both of these photos are full of character and charm, but if the blonde girl were your child, you'd probably prefer the open-eyed expression in the photo on the right. (Photo: Allison Cottrill)

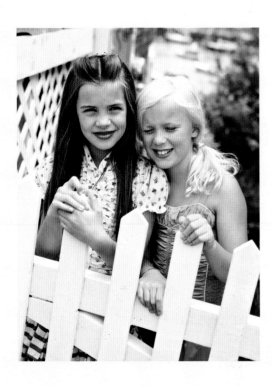

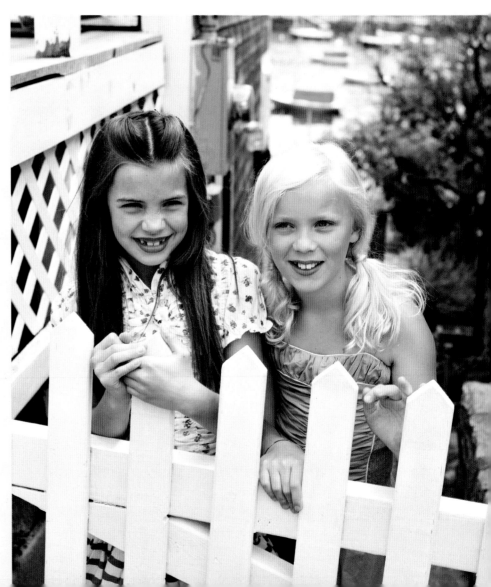

Angle of Light

As we shall discover later in this section, the angle of the light in relation to the subject has a significant impact on an image. When using backlighting to light a subject (so that the light is slightly behind the subject and pointing toward the camera), I always adjust my body to make sure the light isn't directly behind the subject, which risks turning the subject into a featureless silhouette. This form of offset backlighting creates a nice, warm glow around the subject. There are other instances when my aim is to highlight the subject's eyes, although I may have to become a bit of a contortionist to make sure the light is hitting the face in just the right way.

One of the best ways I've found to bring out a child's eyes is to take him or her outside into open shade. This is an open area where you are completely covered by shade, with no sunspots on the ground. Position your subject so that the sun is behind you but not shining directly into their eyes. This type of lighting will ensure the subject's eyes are lit and alive, not flat and lifeless. This lighting also helps to keep the subject's face evenly lit, so that there are no visible patches of light on either the face or clothing. These patches can be distracting and detract from the intended point of focus — the face.

DEPENDABLE, EVEN LIGHTING
A murky fall day provides gentle, even lighting that shows off soft, delicate skin to its full advantage. The dark vignetting effect is partly a by-product of lens design and partly enhanced in image-editing software to frame the subject. (Photo: Alicia Rupprecht)

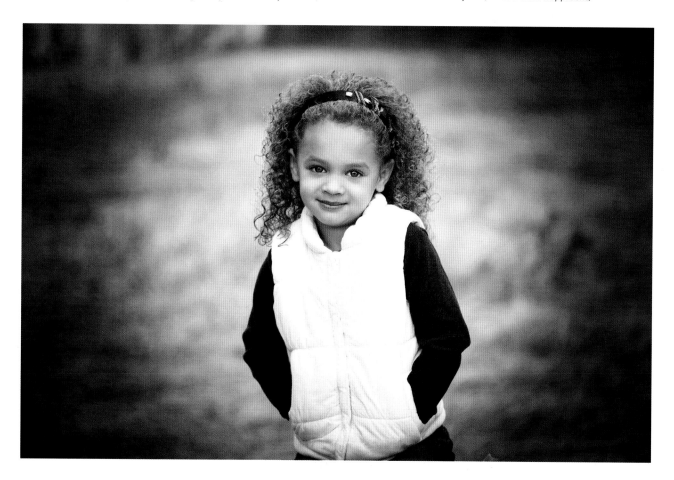

Finding the Best Light

Familiarizing yourself with various types of light and how the angle of light creates different effects allows you to take your photography to the next level.

The most effective way to discover the best light is through experimentation. Once you have identified a location for your next shoot, grab a doll or teddy bear and photograph it to see which lighting works best. Try photographing it with the sun behind you so that the light is shining more or less directly onto the subject. Try with the sun to one side or even behind the doll or teddy so that the light is shining into the camera. Remember to hold your practice sessions at the same time you're planning to photograph your child. This will give you the most effective preparation. Also, experiment by placing the toy in slightly different places around your location (from open sunshine to shade, for example), then change your position to create different angles. This way you'll determine which is best for your ultimate vision.

If, having studied your practice shots, you're unhappy with the results, don't give up! Expand your shooting times to capture the sun at different positions in the sky; this will give you greater lighting variation. Because you are going to get very different results at different times of the day, take note of which you prefer and which do not appeal to you. Always remember to keep checking your subject's eyes to make sure they appear brightly lit. In your practice runs try to use a doll that has lifelike eyes — if these appear flat and dull when you examine your practice shots, it's likely that your child's eyes will also look flat and dull when it comes to the real shoot.

Look into the Eyes

A good tip for avoiding flat, dull-looking eyes is to look for "catch lights." When a subject's eyes are well lit, you should be able to see little specs of bright light that add a little sparkle and make a statement. These are always something you want to strive for, as opposed to flat light, which will

SPARKLY EYES
In this pair of simple yet effective images, square catch lights can be seen clearly in the little girl's eyes. (Photos: Sandi Ford)

Looking away from camera but toward one of the studio lights.

LOYAL SUBJECT
When you're learning about lighting, take lots of shots using a doll or plush toy to practice.

Looking into the lens and one of the three lights used for this shoot.

Overexposed, but stylishly so.

Warmer tones with correct exposure.

add dark circles to the face. Finding the right mix of enough light to brighten the face but not so much to wash out a child's features is important.

Too much light will also create what are known as hot spots or blowouts. These bright white, featureless patches can occur when strong light is reflected back from the subject's face or clothing. Unfortunately, this is a common error and one that I still make myself if I am not looking out for it.

Watch for Underexposure

When paying particularly close attention to the lighting as it appears on a subject's face, it can be easy to overlook the lighting in the rest of the frame. Often, if a subject's face is well lit, the camera may underexpose other parts of the image, often the background. Underexposure is a common error and can prevent your images from looking crisp and clear. As appealing as it may be to get creative with your lighting, you must first start with the basics, and making sure your subjects have an adequate amount of light is as simple as it gets.

If you're using an automatic camera with a flash setting, try turning off the flash for the time being, because a flash can produce unattractive, flat lighting. Move into an area with more light if necessary — an open shaded area is ideal. This will allow you to control the amount of light falling on your subject. If you're using a semi-manual setting such as aperture priority, you can set the aperture, and the camera will automatically set a shutter speed appropriate for the light level. Take a shot and use the camera's histogram (see box on pages 36–37) to ensure that the image is accurately exposed.

Using the LCD display to "eyeball" the image is not going to be enough and can be deceiving. Some display settings on equipment can be too bright or may dim over time, thus giving you a false perception of what your image actually looks like; therefore, always use the histogram. You can always use the camera's EV adjustment to manually increase the exposure to ensure the background is well lit.

WHITE HAZE
Overexposure created blowouts in the image at the far left, but it does add a certain visual style to the portrait, which you might like. Compare with the image to its right, which is correctly exposed and more conventional.

Avoiding Noise

When photographing children I suggest a shutter speed of no less than 1/125 second — anything below that and your subjects might appear blurred due to their movement. You might find that the light level won't allow for this shutter speed (even with the widest aperture setting), in which case your option is to raise your camera's ISO setting. Increasing the ISO makes the sensor more sensitive to light and allows you to set a higher shutter speed. However, only increase the ISO setting if you're using intermediate or advanced camera equipment. Any high-end camera will allow you to raise the ISO (to around 800 or so) without adding noticeable noise to your images (see page 28). While lower-spec cameras also allow you to increase the ISO setting, this will usually add an unacceptable level of noise to your image — another drawback to small sensors. If this is a common occurrence for you, leave the camera at its base ISO setting (usually 100) and only shoot in good lighting conditions.

HOW TO READ HISTOGRAMS

Histograms are an accurate way of gauging the exposure of your images. Although they may at first appear very technical, histograms are quite easy to follow. The histogram displays all the tones present in the image. Black tones, such as shadows, are shown at the left of the graph, while paler and white tones, including the highlights, are shown to the right. Of course, you might want your image to be under- or overexposed to add to its style, but it still helps to know which way it will turn out, giving you control over the outcome.

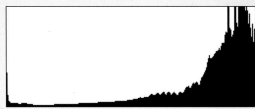

OVEREXPOSED
In this shot, the graph is pushed up against the right-hand side. This tells us that lots of pixels will display as white or close to white, which indicates an overexposed image. The image does look bright, with much of the background detail blurred into shades of white.

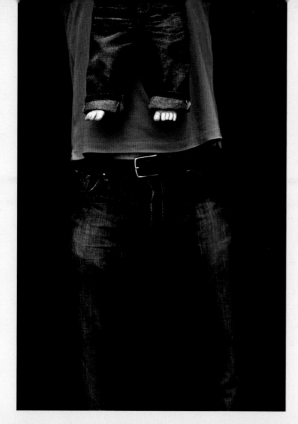

UNDEREXPOSED

This image is dark (see page 57 for the correctly exposed version) — the background is black and it's hard to see the man's jeans in certain areas. When we look at the histogram, we can see the graph is bunched up on the left-hand side. This indicates that lots of pixels are pure black. If your histogram looks like this you know your image is underexposed and that you need to adjust the settings if you want a brighter image with full detail.

BALANCED EXPOSURE

The histogram for this image is relatively evenly spaced between the black and white points. This indicates that there is an even range of tones present. The fact that the graph is bunched neither to the left nor to the right shows that there aren't too many pixels that are either pure white or pure black.

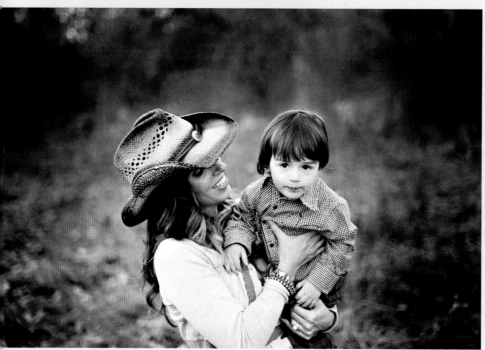

Types of Light

When shooting with natural light, there are many different variations that you can use to dramatically vary the look of your images.

If you were to ever shoot the same location at the same time every day for a week, you would undoubtedly yield different results each time (depending perhaps on where you live and the time of year). Cloud covering, storms and haze can all create unique lighting situations. Personally, I love the steel-blue colorcast I get when shooting right before a big storm. The dark gray cloud covering has a unique effect on the images, providing my subject with the perfect amount of even light.

Lighting Scenarios

Any photographer will tell you that unbroken midday sun is usually the most difficult light to work with. The harsh sunlight at this time of day creates highlights that "blow out" in a bright, white haze. Shadows are also severe, and the strong contrast between highlights and shadows can leave your subjects looking washed out. If you have to shoot under such lighting, I would suggest turning the flash on (or attaching a flash) and using its bright light to "fill in" (or lighten) the dark shadows for a more evenly lit appearance.

SOFTENING THE LIGHT
This makeshift sunshade is not only protecting delicate skin from harmful rays, but it also helps to soften the light, creating a cool environment for a shadow-free portrait. (Photo: Amy Wenzel)

FLASH FOR FILL LIGHT
Even in the brightest conditions your child's face may be in shadow, depending on his or her relative position to the sun. In this case, use a flash to throw some extra light onto the face so that it doesn't appear underexposed. When used in this way, flash lighting is known as fill or fill-in flash.

For my beach sessions when the light is at its harshest, I try to find a covering under which to shoot my subjects. Alternatively, I'll bring some form of sunshade under which the subject can stand. If neither of these options is available, turn the subject's back to the sun (not possible at noon when the sun is directly overhead) and make sure their face is angled to prevent those unflattering shadows from taking over the space between the brow bones and under the eyes.

HAIR HALOES
Use backlighting to highlight soft textures, such as hair and clothing fabrics, for a glorious halo effect.

What Works for You

Finding your favorite light can boost your image quality and confidence. My personal favorite is romantic backlighting. For me, this is found at dusk; for all you early birds out there, this effect can also be accomplished at dawn. To achieve the best results at this time, I use a lot of backlighting, which is when the sun is directly in front of you and behind your subject. This light creates a romantic, soft glow around the subject, which elicits a warm, comfortable feeling.

With the sun behind the subject, his or her face will be in shadow, so use a flash or a reflector to throw light onto your child's face. Photographers' reflectors are either silver or gold and help to bounce the light from the sun back toward the subject's face and eyes, giving a healthy glowing complexion. For the more resourceful type, a simple whiteboard found in most craft or office supply stores will work wonders. Another helpful hint is to wear a white shirt while shooting — this will reflect a surprising amount of light back onto your subject.

Side Lighting

Those of you who are feeling more confident can experiment with side lighting, in which, as its name suggests, the subject is lit primarily from one side, leaving the other side in darkness. It is considered the most artistic and difficult natural light to play with. When done correctly, side lighting can make for a dramatic image — but be mindful that, when used incorrectly, your images can appear messy and disjointed. While you may be able to pull the look off with automatic settings, this technique is best used with manual control. As a rule of thumb, set the exposure for the highlights not the shadows. If your camera has a spot or center-weighted metering option, use this to take an exposure reading from the brightest area. This will require a lot of practice, but try not to get frustrated if at first you don't succeed. Once you've mastered it, the wait will have been well worth it.

Moving Subjects

The best light for shooting small moving subjects — which children usually are — is in open shade. The sides of buildings, alleyways or under large trees (avoiding the sunspots between the branches) are ideal locations, allowing you to focus on your child rather than having to adapt to ever-changing light conditions.

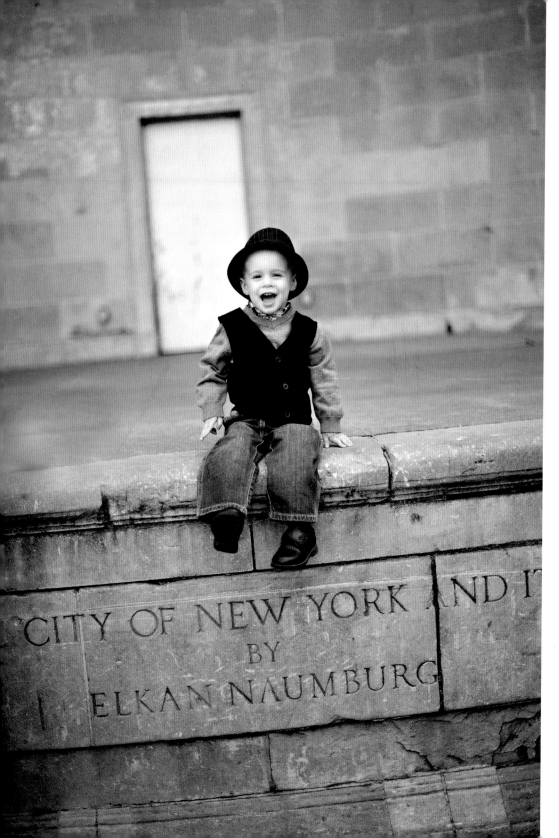

POWERFUL PORTRAITS
Opposite: Add a little drama to your images by placing your subject so that the light falls on one side only. This creates a contrast between the left and right sides of the face and body, making for a creative portrait.

STICK TO THE SHADE
To avoid potentially distracting shadows that can make an image look messy, when shooting on a clear, bright day, seek out an area of open shade, such as under a thick tree canopy or in the shade of a building.

CHAPTER 3
Think Like a Pro

"A photographer went to a socialite party in New York. As he entered the front door, the host said 'I love your pictures — they're wonderful; you must have a fantastic camera.' He said nothing until dinner was finished, then: 'That was a wonderful dinner; you must have a terrific stove.'" — Sam Haskins

So you've read hundreds of reviews, spoken to a ton of keen photographers and a couple of pros and purchased what you believe to be the best camera within your budget. You've read the owner's manual, taken a few online courses to hone your newly learned skills and feel as if you know your way around your equipment. However, you're still getting the same results as when you were shooting with your older, cheaper compact. Why? Photography comes from two places: from technical equipment, of course, but also from within. You need to learn to think like a pro. Until you learn how everything blends together — light, color and composition — your images will never be more than snapshots. It's never just about the camera; it's always about the photographer.

Choosing Your Style

Styling can be the most creative way to allow your children's unique personalities to shine through.

Whether you choose a look that's traditional, modern, fun, whimsical, candid or spontaneous, the styling should support it. On these pages, we compare some contrasting approaches to children's portraiture.

FUNKY

For those in need of a little more guidance on the subject, tutus with jean jackets are always a fan-favorite, as are cowboy boots paired with your child's favorite plush toy. These seemingly contrasting styles end up coming together for a haphazardly brilliant color scheme, making your resulting photos look spontaneous and full of life.

- Pair bold colors and layers to create fun contrasts.

- Experiment with uncommon clothing combinations and use the focus of the image.

- Let your child take the lead by choosing key pieces from their wardrobe.

- Have fun and be spontaneous! Let your child play with a favorite toy.

- Choose opposing outfits and locations, such as a princess gown against an old building as a backdrop.

A knitted hat and a ballet tutu, what's not to like?

What's cute here is that Milly is absorbed in the flower and oblivious to the camera.

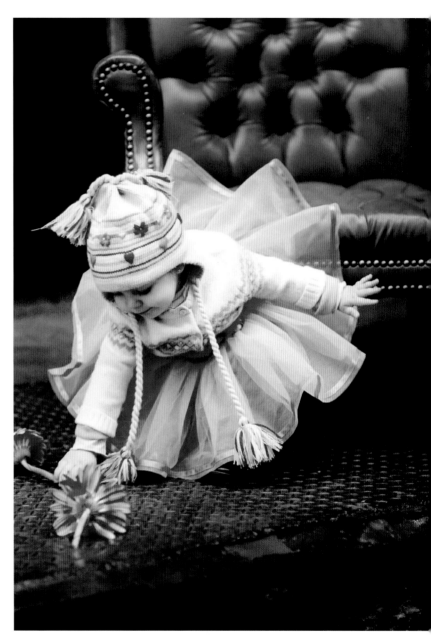

Technical information

Aperture	*f*/2
ISO	200
Shutter speed	1/100

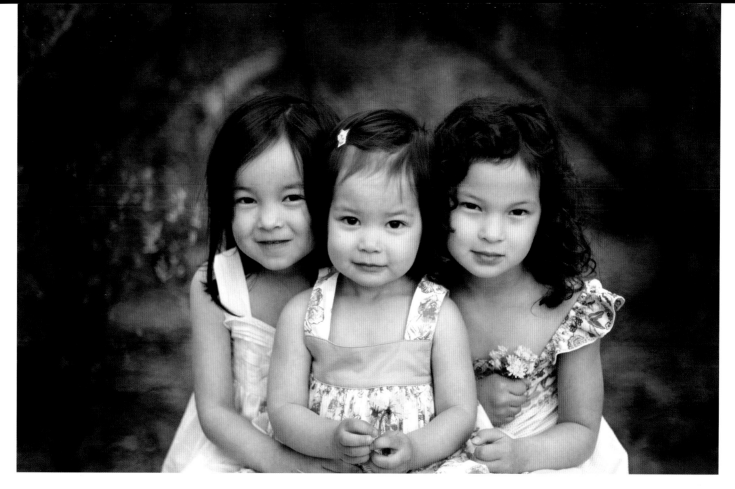

TRADITIONAL

. .

There are plenty of creative options in line with this style for your family to choose from. As an alternative to the stiffer, color-matching "school uniform" look, you can achieve the same overall feel by matching general color tones instead. Remember, the colors don't have to match exactly; they just have to complement each other. This prevents your subjects from looking too similar.

■ Loose-fitting clothes, solid colors or white work well. Avoid busy patterns, logos and clothing with any text.

■ Try not to focus on matching or creating a monochromatic look; instead, use complementary colors and tones.

■ Choose simple backgrounds that don't compete with the focus of your image.

What really makes this image so engaging is the sisters' expressions, each distinctive and none hamming it up for the camera.

The children are arranged formally, with the youngest in the middle.

Looking directly at the camera, with the knowledge that they are posing for a photograph, brings formality and a sense of occasion to the image.

Technical information

Aperture	*f*/1.4
ISO	200
Shutter speed	1/1250

More styles to consider on the following pages ➡

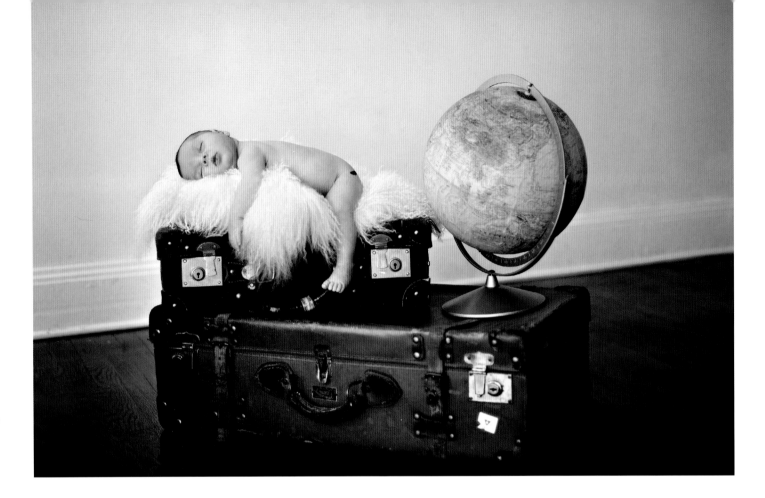

STYLED

Whether at home or on location, you can use a variety of props to style your shoots if you want to set the scene and enhance a particular theme or message. Old retro objects or antiques, like these suitcases and globe, are not only attractive objects in their own right; when paired up with a newborn baby they appear to tell a tale and make for a great visual pun — the image shouts "old and new." Keep an eye out for props like these when you're visiting antiques fairs and markets.

- Use objects that complement each other visually and share a similar theme.

- Don't be tempted to use too many props, otherwise the image will look cluttered and your little guy will get lost.

- If shooting at home, ensure that there's nothing on the walls or visible in the frame that breaks the theme.

A young adventurer in the making?

The props are important to tell the "story," so make sure they're clearly visible.

Technical information	
Aperture	**f/2**
ISO	**200**
Shutter speed	**1/250**

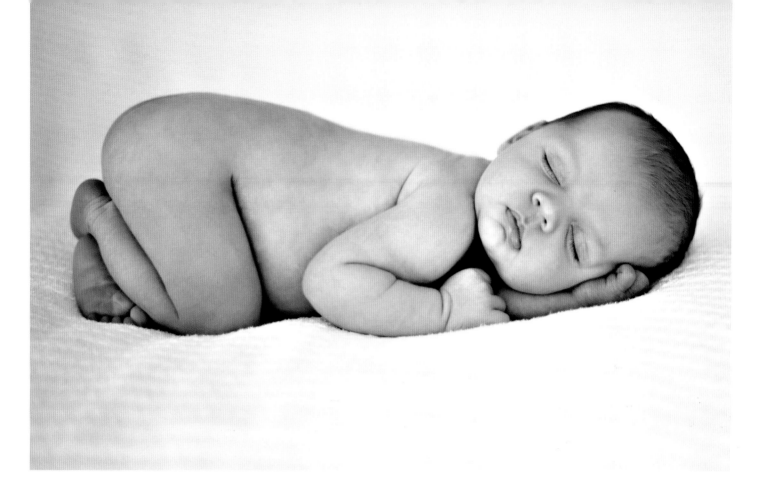

MINIMAL

Sometimes less is more, and one of the most effective ways to photograph babies and children (and adults, for that matter) is to pare right back on props, find a neutral setting, zoom in close and try a black-and-white treatment. With no visual distractions, viewers can focus 100 percent on the subject of the photo — plain and simple and just perfect. For more ideas on shooting simple pictures, turn to Keep It Simple, pages 60–61.

- Photograph your subject in front of or on a white sheet or blanket — white is the ultimate minimal color.

- Use your camera's black-and-white setting if you're not going to edit your photos on a computer.

- Soft, diffuse lighting works well for a minimalist style, so avoid direct lighting that can cast dark, distracting shadows.

For older children, use cream or white clothing or zoom right into the head and shoulders.

Use the widest aperture (smallest f-number) and focus precisely on the eyes; this will blur the background.

Overexpose a little for a light, airy feel.

Technical information

Aperture	*f*/1.4
ISO	200
Shutter speed	1/250

COMEDIC

Kids love to joke around, so photographing them in the act can produce great, natural-looking, unselfconscious photos that you'll treasure forever. To get them in the mood, look for funny props and outfits — in no time at all they will have devised a comedy routine ready for you to photograph.

- Leave kids to horse around in costumes for a while before shooting.

- Don't try to shoot all the action; get them to think of a pose they like and set that up for a shot.

- Photograph in a clutter-free setting with few visual distractions, making the kids center stage.

- Use continuous shooting mode to capture lots of frames quickly — expressions change when in funny poses, and it's good to have a selection.

Get in close to the action to cut out unwanted background elements.

In this instance, encourage them to play up to the camera!

Technical information

Aperture	**f/4**
ISO	**250**
Shutter speed	**1/500**

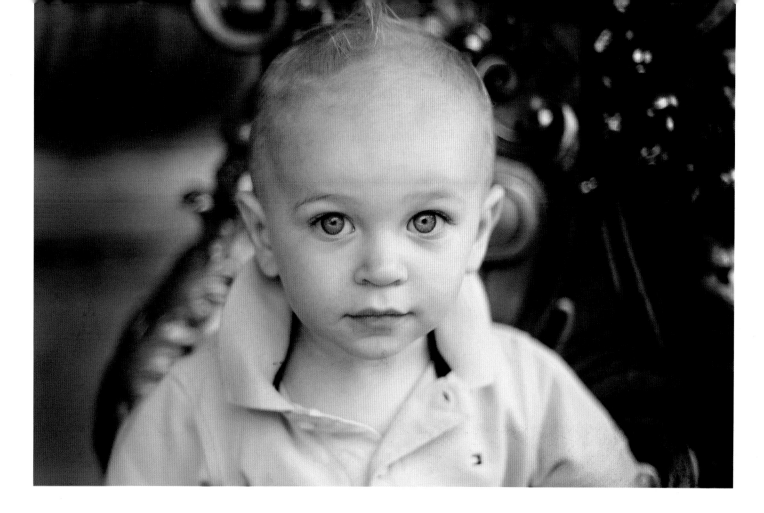

PORTRAITURE

The classic head and shoulders portrait looks very simple, but it is surprisingly difficult to get right. The lighting, the expression, the styling, the background and the clothing all have to look natural and work together, otherwise the viewer's attention will be distracted from the subject. But when all the elements are just so, you'll be blessed with an unforgettable image that captures the essence of your child.

- Lighting is crucial. Soft, diffuse light is perfect, so shoot indoors or outdoors on an overcast day to avoid strong shadows.

- Make sure the clothes and background complement your child's skin tone and eye color.

- Ask your child to be calm, to think happy thoughts and to look directly and evenly at the camera.

The open gaze and neutral expression make this portrait a success.

Shoot at eye level to your subject.

Move or zoom in until the head and shoulders fill the frame.

Technical information

Aperture	f/1.4
ISO	200
Shutter speed	1/250

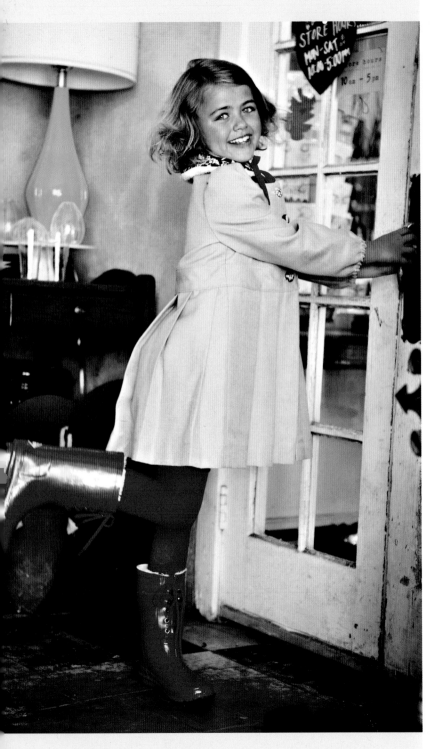

How to Achieve Your Look

There are no great secrets to achieving the perfect look in your images — it all comes down to finding the right ingredients and mixing them together to create the ideal image.

But what do you do when your creative mind isn't pulling its weight? The first step is to find some inspiration. Scour the Internet to find out which photographers you are drawn to.

When you've narrowed your list down to your top-five favorites, ask yourself these things:

- What elements does each photographer have in common?
- Are you drawn to fun, bright and bold images or romantic, soft and vintage-styled images?
- Do you prefer interior or exterior, city or wide-open spaces?

This simple exercise will help you identify your overall style interests. From there, try looking at nonphotography books and websites for inspiration. Home-style blogs and interior design books and magazines are great resources for this kind of work. My guilty pleasure is spending an entire weekend lost in old antique shops and quirky vintage stores, and before I know it I am overflowing with some really great ideas to work from — and a few great props to work with.

BRIGHT BOOTS
Momentarily lost for inspiration? Ask your young model to go fetch her favorite, most colorful item of clothing. These boots make the image, and the red is carried on through the tights and the tie around the neck, made all the brighter by the pale overcoat. (Photo: Kelly Roper)

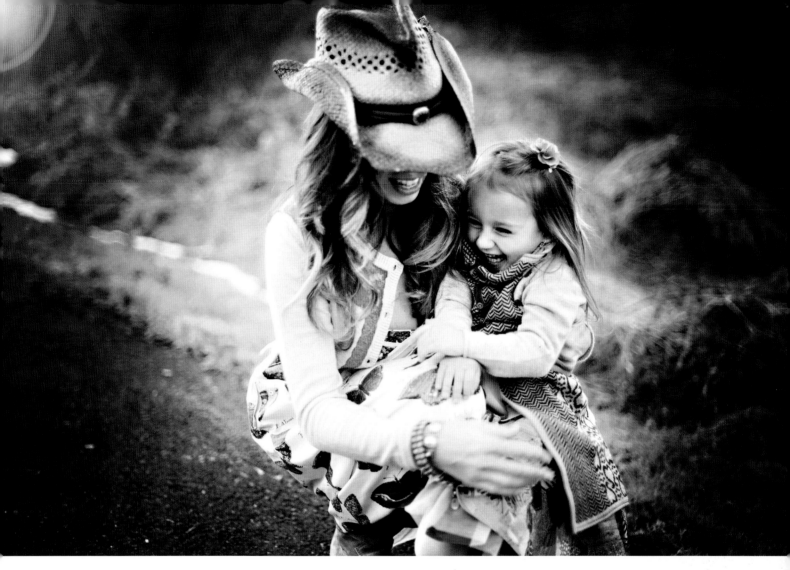

CREATE A VISUAL NOTEBOOK

To keep your thoughts organized, get a plain notebook into which you can paste the images that you find appealing. Write notes on each page next to the images for future shoot ideas. Aspects such as items of clothing, furniture, locations and hair ideas can all be combined on each page to create a complete photo-session plan. Without knowing it, you've just made yourself an entire book filled with ideas for spur-of-the-moment shoots.

Inspiration checklist

- Analyze other photographers' work on the Internet.

- Scour clothing and interior design websites and look at ideas for outfits, color and style.

- Rummage around antique shops and seek out all things retro and quirky.

- Put everything of interest in your notebook — images and notes — for future reference.

COWGIRLS HAVE ALL THE FUN
An old straw hat was the catalyst for this shoot. The rest of the outfits feature complementary colors rather than cowboy authenticity, but the look is there, and then it's just a case of letting loose!

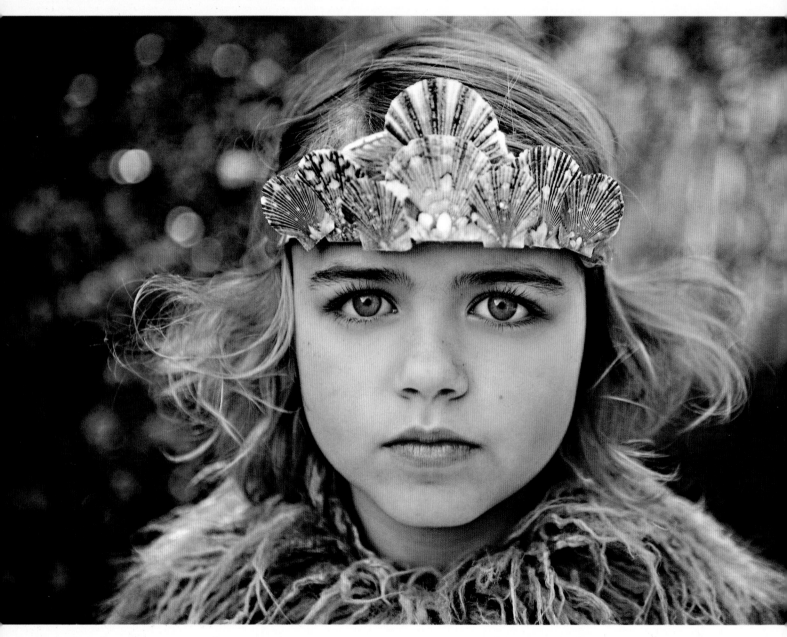

PURE AND SIMPLE?
A simple portrait, yes, but the colors of the shells and the furry shawl complement the light brown hair and skin tones, which in turn set off the green-blue eyes, which themselves echo the background colors! It's all in the detail. (Photo: Kelly Roper)

Making Images Pleasing to the Eye

This is where most people really need to put on that "pro" thinking cap and step outside the box.

Have you ever seen the way photographers or directors are portrayed in movies, forming their hands into a rectangle, as if they're peering through a lens and looking at the set? Believe it or not, this isn't just for show, despite the cliché it's become. Try this the next time you are considering a location. Form a rectangle with your hands and really look at your "set." Are there garbage cans cluttering the image? Is a parking garage visible in the background? These are things you'll certainly want to exclude from your images, since they are distracting to the viewer and can take away from the message that you are trying to convey. Always be on the lookout for unflattering extras that can slip into your shot if you're not careful.

It's All In the Detail

In addition to the more obvious aspects to investigate before your shoot, there are smaller details to be mindful of as well. For example, when I shoot dads with their young children or babies, I always ask them to remove their watches, no matter how inconspicuous they may appear. When seen within the perspective of the entire image, a watch can be distracting, because the viewer's eye will automatically be attracted to the band.

Similarly, moms also need to be mindful of hair ties on wrists, poorly manicured nails and large hair bows that can dominate a little girl's head. Making sure clothing is freshly pressed and faces are clean is equally important. While we want our children to be able to relax and have fun, making sure these small details are taken care of in advance will help keep stress levels down when it comes to the shoot. Keeping your children in play clothing up until the very last minute will also ensure that you are not fussing over them too much while you're busy putting the last-minute touches on the set.

QUICK CHECK

Not just a visual gag that says "movie director," making a viewfinder with your fingers and hands can help you to visualize a shot without raising the camera to your eye.

MAKE YOUR OWN VIEWFINDER

One trick that a number of professionals use, both for themselves and as a teaching aid, is a large cardboard "viewfinder." This helps you frame your images and really see what is and what's not in your shot. Although these are available to buy, they're very simple to make.

1) Get a piece of cardboard; the back of a cereal box is ideal.
2) Cut a rectangular hole using a craft knife. The shape of the hole should match the aspect ratio of your camera. Check the camera's manual if you're unsure what this is. Common aspect ratios are 5:4, 4:3 and 3:2.
3) Leave a border of about 1 inch (2.5 cm) around the rectangular hole.
4) Paint one side of your frame black.

You now have your very own viewfinder that will help you previsualize and frame potential shots.

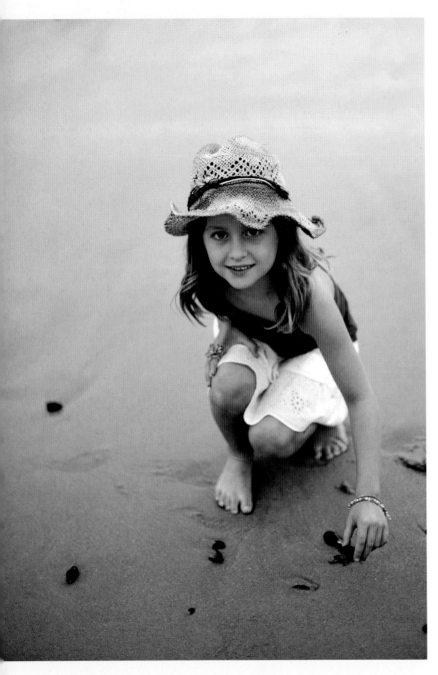

Rule of Thirds

Do you ever wonder why some images capture your attention more than others? Or why some photos appear more evenly balanced than others?

The reason that some pictures just seem to work better than others is often attributed to something known as the rule of thirds. While most rules are meant to be broken, this is one that — certainly if you're relatively new to photography — you're going to want to follow. Although it may sound technical, understanding the rule is not as daunting as it may first appear.

Picture a Grid

Imagine drawing two horizontal and two vertical lines spaced evenly apart from the edges of your image. These lines will create three horizontal and three vertical (hence the name of the rule) evenly sized regions running along and across the image — or a grid of nine regular rectangular sections. Looking at the grid, you'll notice that the lines cross one another in four places. These intersections are often referred to as power points. The rule of thirds suggests that because the eye tends to naturally go to these intersections when viewing images, it makes the image more visually appealing when the subject or subjects are placed on these power points rather than in the center of the frame. That's it. Simple.

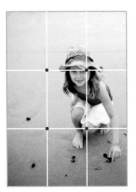

DIVIDED VIEW
Next time you're looking through your viewfinder, try to imagine this invisible grid over your subject — in fact many cameras have a rule of thirds grid that you can turn on and off — and move your camera in order to place your subject's face or body at these strategic intersection points.

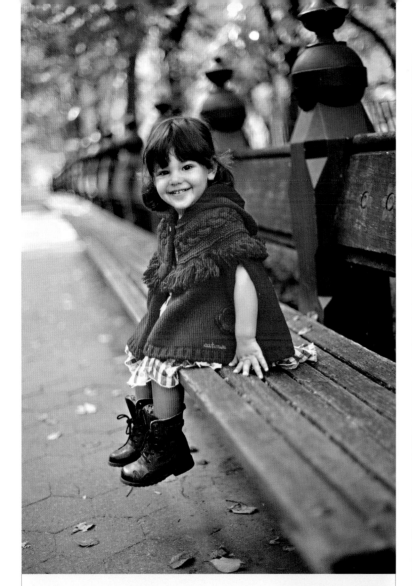

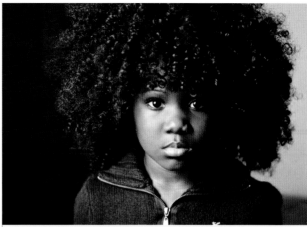

BREAKING THE RULE

While it's good advice to compose using the rule of thirds, particularly when you're starting out, as your eye develops, don't adhere to it so closely that it inhibits your own creative urges to experiment with alternative subject placement. There will be times when placing the subject in the center of the frame just looks better, particularly if you want to emphasize the symmetry in someone's face, for example. Alternatively, placing your subject at the very edge of the frame can create a sense of drama. So feel free to experiment, but if you aren't trying to make a deliberate visual statement, keep the rule of thirds in mind.

 This girl's beautifully symmetrical features framed in a halo of dark curls just cry out to be placed in the near-center of the frame. When facing straight to the camera so that symmetry is enhanced, a central position makes good visual sense. (Photo: Liz Brown)

COMPOSING WITH LINES

Using lines to tell a story in your image is another way to add a little more drama to your photograph. Next time you are shooting, try to notice where the lines lead and try to angle your subject along these lines, leading away from your image. Here, the lines on the bench lead us neatly to the subject of the photo.

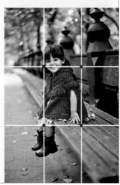

Look for Color

It's easy to underestimate the power of color. While we're not always aware when colors complement one another, we sure know when they clash.

So which came first, the chicken or the egg? I guess we will never know. The same holds true when looking to properly design your image. Whether you choose the colors of the clothes first or the location, it doesn't matter — what is important is that the colors of the latter work with those of the former.

Getting a Feel for Color

Let's say you choose the location first. Every day for a year you have been passing by the same brick alley with a great cobblestone walk. Take a mental snapshot of the area, and use your artistic producer's head to get a feel for the colors you're seeing in the shot. Take note of the warm brick tones and cool walkway hues, and maybe even some black and gray pops thrown in for good measure. Now take out the notebook you've been keeping and write down all the colors you see. With this scene in mind, begin to plan the wardrobe. When thinking about outfits for a specific location, try sticking with the same tones, but don't be afraid to get creative. Make sure to add textures to the outfits, just like the intricate aspects you can see in your location's features.

Shooting at Home

If you're taking a more at-home approach — hoping to get the best images during your daughter's birthday party, for example — then pay close attention to color details in everything you see, from the color of the walls right down to the party hats. This will help you tie everything together and create a more balanced final image.

It even pays to think about how the color of the light outside changes during the course of the day. Sunrise can often bring warm oranges and reds. As the day progresses the light becomes more neutral, returning once more to softer, warmer hues as the sun sets. If you have a Tuscan theme in your home, try shooting during sunset, since the gold hues and warm colors will really pop when displayed on your walls.

COLOR WHEEL
One inexpensive device that will help you get to grips with the rules of color is a color wheel. This is available in art stores and shows you which colors are complementary, which are harmonious and which are toning. Complementary colors sit opposite one other on the wheel and create the most vibrant color schemes. Harmonious colors sit together anywhere on the wheel and are guaranteed to work sympathetically with each other. Concentric rings show the different strengths of each color, with the lighter value in the center moving out toward the darker value on the outer edge. As a general rule, make sure your composition has a range of contrasting values. Interior designers use color wheels to create specific moods, so why not use the same tools in your photography?

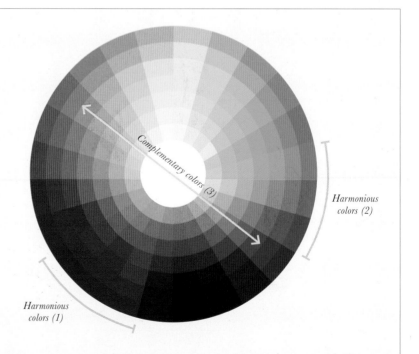

Complementary colors (3)

Harmonious colors (2)

Harmonious colors (1)

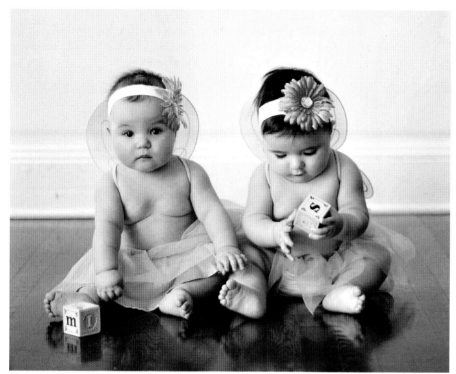

Harmonious colors (1)

Harmonious colors (2)

Complementary colors (3)

MAKE A STATEMENT

Top left: Just as color can be used to link people or themes, it can also be used to express individuality. Although the two outfits here are identical in form, the colors represent two individual characters.

COLOR THEMES

Top right: You can use color (and in this case a specific type of garment) to link people together. This image speaks of fatherhood, without us even seeing the faces. The black background works well with the dark tones of the jeans — the linking theme would have not been so powerfully portrayed against a white ground.

MIXING IT UP

Left: Bright colors are fun and uplifting, and characterize youth. When using lots of bright colors, be sure to find a backdrop that works with the principal color theme, as shown here. (Photo: Aneta & Tom Gancarz)

Look for Pattern and Texture

Being aware of the patterns and textures in your location can help you choose the right props and outfits.

No matter which location you choose to photograph, it will have its own unique sets of patterns and textures. It's important that you're aware of what these are so that you can dress your children and the "set" appropriately. If you are heading to the beach, for example, try bringing in crisp lines and flowing tops and dresses. This will complement the nature of the waves and sand. If you're choosing a more urban setting, make sure to include some nubby textures with knits, wool or tulle. This will take simple clothing and give it as much character as your setting. Although these details may seem bothersome and unnecessary at first, it is these seemingly insignificant elements that can take a nice photo and turn it into a striking and memorable image.

Don't Lose Your Subject

It may sound strange, but adding texture to your images also prevents your subject from getting "lost" in their clothing. While you may think that solid, matching colors are the best way to plan your outfits, be mindful of the consequences. Plain, nontextured or solid-color clothing tends to appear flat and two-dimensional when photographed and can swallow up your subject. Breaking up a plain white polo shirt with a sweater vest and necktie, or even a jean jacket, will add more interest to each image and make your child stand out. This is a great idea if your child is characteristically unique. If your son is typically the comic relief in every situation, accentuate his personality and add a little something extra that reflects this side of his nature. The more outside the box you get, the more fun the entire shoot will be, and it can possibly yield some unexpected results.

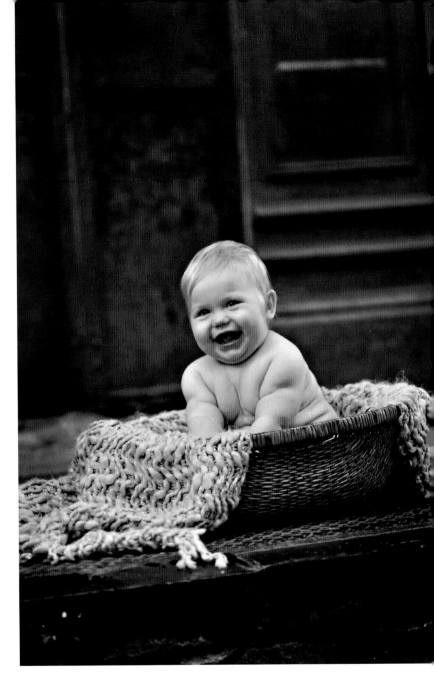

TEXTURIZED TO THE MAX
This image oozes texture, from the wicker of the basket through the wool of the shawl to the black metal on which the basket's sitting. These are very strong textures that we can feel as we look at the image, and all of which contrast powerfully with the soft, smooth skin of the subject.

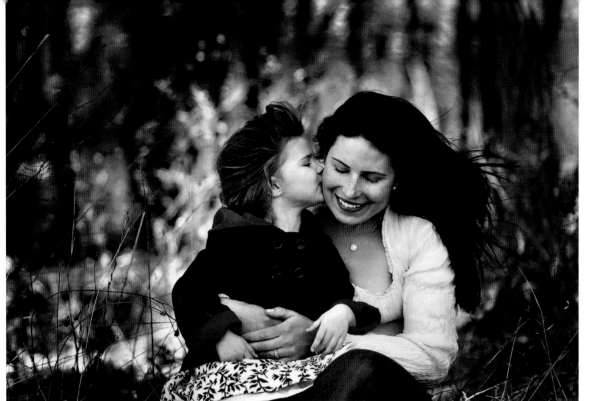

NATURAL TEXTURES
Nature is queen of the textures. Here a delightful mom and daughter's pose is enhanced and framed by the textural grasses around them, and the tree bark and ferns provide further texture in the background.

PLAYING WITH LINES
As tempting as it might be to use plain, flat colors, unless these are broken up by texture, they tend to overpower a portrait. In this photo the boy's face is nicely framed by the striped shirt and the textured V-neck. Vertical lines run throughout — in the background and on the subject.

Keep It Simple

Less is more — or it certainly can be when you want to create images that have impact.

You may have heard of the KISS method — keep it simple, stupid. Well, of course I'm not calling you stupid, but I am absolutely telling you that, when in doubt, keep your images simple. This advice works on two levels: first from a practical point of view, and, secondly, from a visual aspect.

Simple Sets, Simple Life

Taking the practical meaning first, the best way to ensure a meltdown from your baby, yourself and anyone else involved in your photo shoot is to complicate even the simplest of tasks. When planning a photography session, just remember to keep everything, from the set location to clothing to the props, as simple as can be. Lots of time fussing with hair and trying to shove chubby baby toes into stiff dress shoes is not the way to go — despite all your planning and scheming!

Children love freedom, so when planning, take the time to include these wonderful childhood attributes. Bare feet and a simple pair of jeans with a white tee may be just what your little tike had in mind. Don't be afraid to scale down your vision so that your child is more comfortable and feels more natural. Work with your child and keep everything as simple and carefree as he or she is. Despite your best efforts, you are bound to get lots of natural smiles and no grumpy faces if you just stick to sweet simplicity.

Simple Shots, Striking Images

In terms of the actual photography, the KISS method is just as valid. Don't overdress your location with so many props or choose one that is visually busy, as this will detract from the subject. Your child's character and unique beauty should be what first strikes anyone looking at your images. Keeping your images free of visual clutter is the most effective way to ensure that the subject of the photo shines through.

PURITY OF WHITE
Opposite: Although lots of plain white should generally be avoided, that doesn't mean you should avoid it all of the time. White can bring a fresh elegance and simplicity to an image.

PROP-FREE
Props can be fun and introduce a certain theme, but often the most powerful portraits are the no-frills versions, which provide a direct line to the character and essence of the subject.

Selective Focus

Deliberately throwing elements of an image out of focus is a surefire way to create professional-looking photos.

Selective focus is just what the name implies — you are choosing to focus on one thing, leaving everything else in the image blurred out. This one little trick seems to mystify and confuse many photographers, but here we're going to break it down so that you can get to use this neat little trick on some of your own images.

Setting the Aperture

Used in a variety of photographic genres, selective or shallow focus is particularly effective in children's portraiture. The easiest cameras with which to create a shallow focus effect are SLRs, either digital or film versions. The reasons for this are twofold. First, it's easy to manually control the aperture (the opening in the lens) on an SLR. Secondly, SLRs allow for interchangeable lenses, and to achieve shallow focus you want a lens with a low *f*-number, such as *f*/2, *f*/1.8 or even *f*/1.4. That's not to say that you can't selectively focus with larger *f*-numbers. For example, many lenses that come with digital SLRs (DSLRs) have *f*-numbers of *f*/3.5. You can focus selectively with this aperture, but the amount of blur won't be as great as with smaller *f*-numbers. Additionally, it's not just DSLRs that permit selective focus. As long as you can set the aperture on your camera then you can create shallow focus.

Apeture Priority

All DSLRs and hybrid cameras, and many advanced compact cameras, have an aperture priority mode. In this mode you can set the aperture and the camera will automatically set a shutter speed that is appropriate for the light level. This is the best setting to use for selective focus. In this mode, set the lowest *f*-number your lens will allow. Autofocus on your subject and take a picture. As long as the *f*-number was around *f*/4 or lower, when you review the images you should notice that the foreground and background are blurred while your subject is sharp. For more on aperture and focus, see pages 22–29.

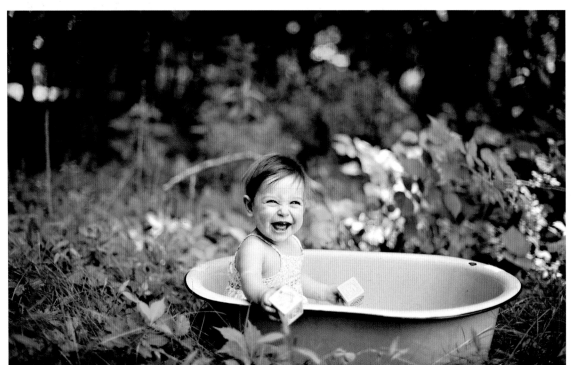

CONVENTIONAL SHALLOW FOCUS
Using a wide aperture and focusing on your child's face will help to blur a potentially distracting background, even one that's as beautiful as this one. The child and her bathtub are firmly in the limelight.

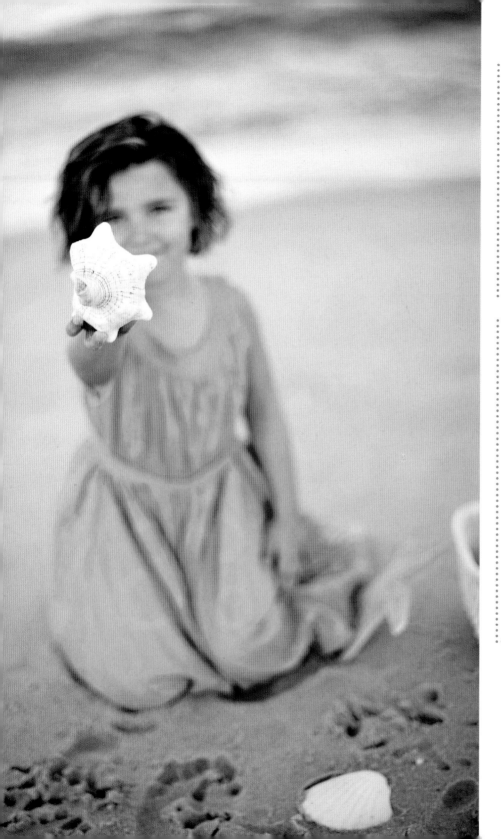

VARY YOUR POINT OF FOCUS

In most cases your subject's face will be the point of focus. You know you've accomplished this when you see the subject in clear focus and all surrounding areas are out of focus. This will obviously attract the eye to your subject, which is the main goal of any children's portraiture. Don't get too comfortable with this format, though. Once you get the hang of the technique, experiment with other focus points. For example, try having your child's hand as the subject of the image, outstretched and holding a flower. This will create a more abstract view with the child's face blurred in the background. You'll find there are lots of creative ways to modify the focus points within an image, and mastering this concept will expand your perspective.

UNCONVENTIONAL SHALLOW FOCUS
There's no law to say that if a person appears in a picture that they have to be in focus. Here, shallow focus is used to make the beach setting the star of the show while still letting the girl be an identifiable part of the image.

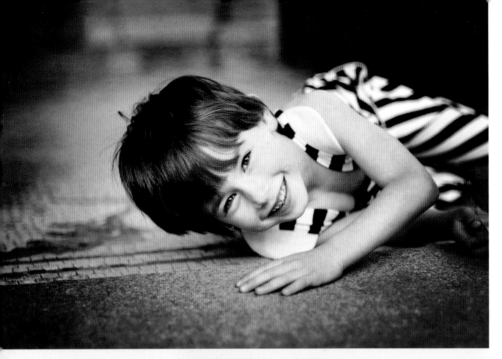

Change the Viewpoint

Don't just shoot at your or your subject's eye level all the time — varying the position of the camera will reap great visual rewards.

If you look through some of your favorite photographers' works, one thing that will probably catch your eye is the different perspectives they use. Whenever I'm mentoring anyone interested in photography, I always ask him or her to shoot around the subject in a circle — walking around the subject, snapping as you go, with your subject as still/stationary as possible — as a learning exercise. Using this trick helps you gain new perspectives and can open your eyes to new shooting angles.

This concept is especially important when you have a stubborn toddler who refuses to move from one spot! Getting low to the ground and shooting upward, as well as going way above your child and getting them to draw their eyes up toward you, adds another dimension to your photography.

Get Down

With smaller babies, lie down on the ground and get at eye level with them. You can also try to mix things up visually by tilting your camera at different angles while shooting to achieve that more modern, magazine look. If you're trying this technique for the first time, just make sure your child never looks as if he or she is slipping off the floor and out of the image, since this will likely provoke the wrong reaction from your viewer. It should be a subtle effect, so the viewer does not quite know why the image looks slightly different.

HOW LOW CAN YOU GO?
Shooting at eye level, even if it means getting down on the ground, helps to reinforce a connection between the viewer and the subject, and it also helps to add variety to your portfolio of images.

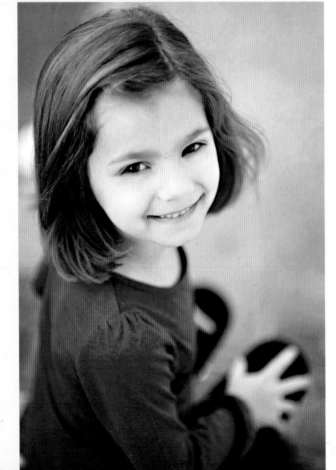

ELEVATED ANGLE
Just as getting down low can add variation, so too can getting up high. Often with child portraits a high viewpoint can emphasize their small size, adding to the cute factor and also playing to our natural protective instincts.

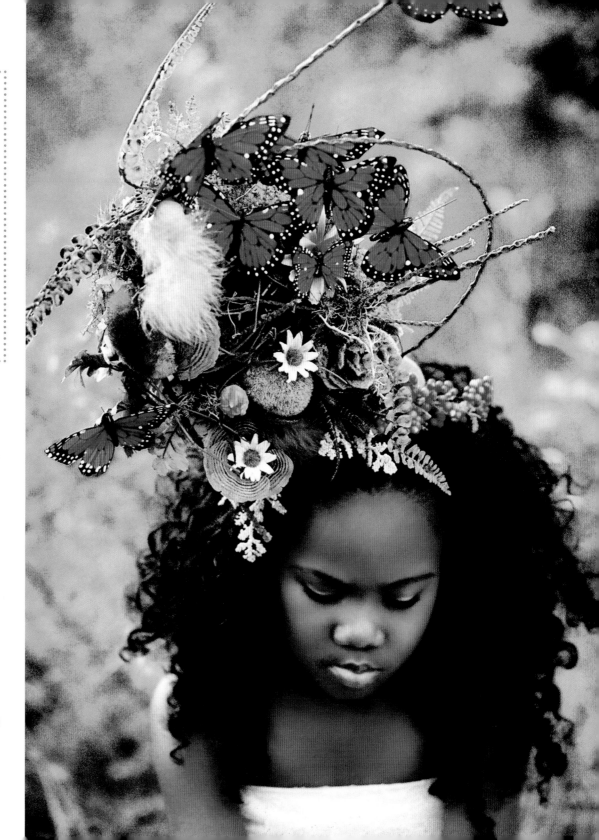

FROM ON HIGH

Try taking the viewpoint to an extreme. Either use a tall stepladder or lean out of a second floor window carefully to look directly down onto your subject. This works particularly well with group shots, where you have a group of faces all looking up toward the camera.

IF THE HAT FITS...
It may be the subject that dictates the angle from which you have to shoot. The only way to capture this astonishingly beautiful hat was to get above the girl and shoot downward. (Photo: Liz Brown)

Foreground and Background

What many new photographers forget is that an image is made up of more than just the subject — you have to design the entire frame to make a successful photo.

Learning how to take better pictures starts with a basic knowledge of how to see things. You may not notice it when looking at objects and scenes around you, but there is always a foreground, mid-ground (which usually includes the subject, that is, the element that you're focusing on) and a background. These are the three basic elements you need to be aware of when you are taking a picture. I have seen many potentially beautiful images go wrong because the photographer is so focused on the subject that he or she forgets about the other two important elements.

Look Before You Click

Say, for instance, that your child is playfully hugging the family's new puppy on the sofa. What a wonderful subject, so you grab your camera and fire away. But in front of the sofa, out of your mind's eye but in the camera's field of view, there is a pile of toys and a coffee table with a juice box leftover from snack time. These extra elements will be in the foreground of your image, and instead of noticing the cute interaction between pup and baby, everyone is going to notice the leftovers in front of them.

Now let's say you are outside in a park with your toddler, and he or she picks up a beautiful leaf and starts to examine it intently. Of course you snap away — but only later do you realize that there is an unsightly garbage can behind your child's inquisitive expression. You now have a background issue.

So the next time you put much thought into the subject and how they look, make sure you give equal amounts of attention to the foreground and background. Of course you can use selective focus to distract the viewer's attention from these areas, but make sure they contain colors, textures or objects that at least complement the subject.

CREATE THE WHOLE IMAGE
If you're including a foreground and background in your portrait, make sure that everything you can see in the viewfinder reflects the mood of the image and complements the subject.

This rustic background complements the theme and style of the shot.

The old bucket reinforces the timeless quality of the rest of the setting.

ENGAGING THE VIEWER

A popular technique with landscape photographers is to frame their images so that the foreground area is filled with something that will draw the viewer's gaze into the frame and onto the main subject, such as a moss-covered rock or a textured tree trunk. Try this same technique with your portraits. At a birthday party, sit your subject at one end of the table and fill the foreground with colorful cakes, fruits, juices and ice creams. Now viewers will be drawn into the image by the colors and work their way up to the subject of the photo. (Photo: Siobhan Murphy)

The out-of-focus foreground frames the subject.

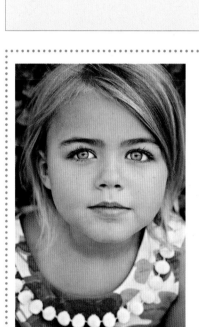

TRICK OF THE TRADE

When stuck in a spontaneous moment and the background and/or foreground are not exactly pleasing to the eye, use the same trick as the professionals and get in close. Focusing on your child's entire face in order to crop out less-than-perfect scenery is the way to keep that picture looking its best. (Photo: Kelly Roper)

Deliberate Framing

Now that you know how to effectively work with the foreground and background as well as the subject, let's discuss how they can make your pictures stand out.

A Frame Within a Frame

A foreground or background object — or combination of objects — can be used creatively to frame your main subject. A doorway, window or even another person positioned in just the right spot can add interest to your image and put your subject firmly in the limelight. Always take a good look around before you shoot and take advantage of any appropriately placed objects — a lamppost that intersects with a railing, for example. You could maneuver other people at the scene so that they are either side of your subject, perhaps blurring them in the foreground or background.

PEEPHOLE
You can use just about anything to frame your subject to give him or her greater visual emphasis. This playground tube mirrors the shape of the baby's head. (Photo: Rachel Hein)

THROUGH THE LOOKING GLASS
This window serves as an ideal frame with which to enclose the subjects' faces. The distressed frame, foreground plants and black-and-white treatment create a special study. (Photo: Ken Sharp)

Land of Make-Believe

Don't necessarily believe those who say "the camera never lies" — carefully framing a small attractive background area can create a near-fictional world. The great thing about working with children is that you only need a small space to make some amazing-looking images. Thinking of your background as a space no bigger than 4 × 6 feet (1 × 2 m) is a great way to begin to capture some sensational backgrounds you may not have thought to use before. For example, my studio is located in a busy area, but clients consistently ask about my outdoor images. To make these images a success when not at an on-location site, we simply walk over to an adjacent parking lot and use a small grassy patch in the back of the lot. People are always a bit apprehensive when I tell them my intentions, but what they don't know is how I intend to use the background. By cropping into that small workable space, their children are somehow transported into a magical woodland and no longer in the back of a lot filled with cars.

With this in mind, as you are walking around in the days to come, take note of that gorgeous patch of flowers in front of your bank, those sweet little café tables outside your local coffee shop or an old gothic-style door or staircase at your neighborhood church. All these details can become something amazing with the right cropping and perfect styling.

USING PROPS TO TELL THE STORY

One way to reinforce the fact that your child is standing in Neverland rather than the mall parking lot is to use props that help the visual myth along. Here I brought in some hay bales for the girl to stand on. These not only add some pleasing color and texture to the image, they also complement the small area of woodland in the background, reinforcing the sense of a rural idyll.

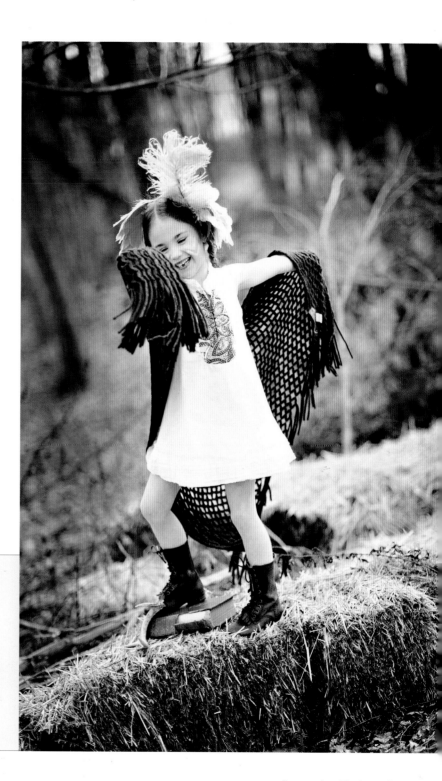

CHAPTER 4
Know Your Child

Any artist will tell you that the key to making meaningful art is being able to connect with your subject. The same philosophy is true of photography. Throughout the years, friends and acquaintances have asked me to photograph anything from pets to weddings. While these seemingly innocent requests appear to be just that, I often shy away from photographing such varied subjects. I have always held the mantra that you should only photograph what you love. Therefore, it's no wonder that I approach every session the same way, using that love as a foundation from which to connect with my subjects. In this chapter we will explore the art of making a true connection with your child to yield the best possible results in your own photos.

Working with Your Child's Personality

As a parent, you have a terrific advantage when photographing your child — you know them better than anyone else.

It can be a real challenge for a professional portrait photographer to get to know a child in 3 to 5 minutes, especially when he or she is expected to capture the child's entire essence within a single photograph. The good news for any parent is that you already know your child inside and out.

Understanding your child's unique personality is your number-one asset when creating at-home images. If you know your son is shy, limit the number of people present during the photo shoot — in fact, it may be best if it's just the two of you. You could even try taking him on various "play dates" to capture his character when his guard is down. If you can, find somewhere peaceful such as a wild meadow, bring his favorite snacks and toys and speak to him with a soft voice while sneakily snapping away with your camera. With this technique you'll be able to bring out his natural expressions without ever actually having to tell him to look at the camera.

CHEEKY CHAP
With bags of energy and a knack for pulling funny faces, this boy exudes character and suits his outfit to a tee.

LET THEIR CHARACTER PEER OUT
Allowing this toddler's hair to fall across her face adds to the cuteness of this photo and reflects her shyness as she retreats behind the stool.

SETTLING INTO A SHOOT

You know what works best with your child, but most children will behave positively with the following in place:

- Make sure your child's happy in his or her surroundings.

- Use toys and games to keep your child occupied.

- Keep talking softly and act naturally while photographing.

- Use a telephoto lens or setting so that your child's less aware of the camera.

Letting Your Child Take the Lead

Trying to force your child to conform to your idea of the perfect photo shoot can often lead to frustration all round.

So you've planned the entire photo session. You've taken great care and chosen each outfit (down to the matching socks). You've searched tirelessly at every local antique shop for the perfect vintage wagon, and you've even convinced a local farmer to let you use his barn as a backdrop. You have the perfect image in mind, the light's just right and you're beyond excited to begin shooting. But just as you position the finishing touches on the set, everything goes awry. Your child has decided that the new outfit is too itchy, the wagon is too old and shaky and the barn in the background is just too scary.

At this point, you have two options. You can beg, plead and bribe your child to cooperate with your vision, or you can let your child take the lead. After years of shooting I've learned that the best images come when you relinquish control and follow your child. Avoid having too many expectations for sessions, particularly if they're contradictory to your child's natural habits. Be prepared to forego the original "shoot list" and see if you can come up with an alternative plan.

FREEDOM OF MOVEMENT
If she doesn't want to pose demurely, let your beauty queen do her own thing — you'll likely end up with some great images. (Photo: Kelly Roper)

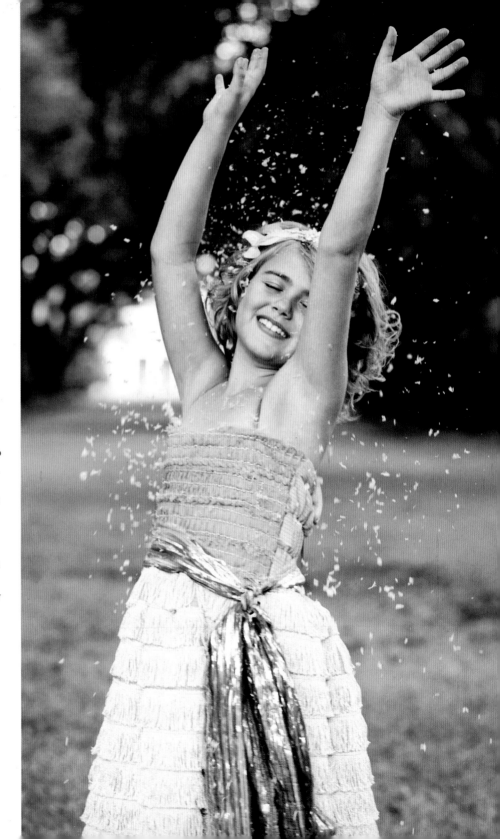

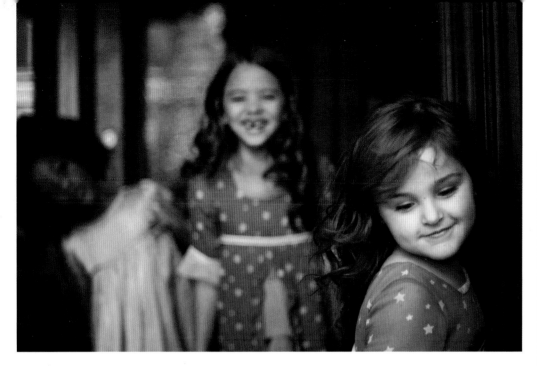

THINK ON YOUR FEET
So you can't get the planned group shot to work? Relax, keep shooting and watch the action unfold for more natural photos.

COMFORTABLE IN THEIR CLOTHES

If you have a particular outfit you'd like your child to wear, wash the items first using your regular detergent. Put the outfit on your child a couple of times without expecting to photograph him or her; this way the clothes won't seem unusual when you do decide to introduce other props and surroundings.

Enjoy Yourselves

By changing your approach and letting your child act first, he or she is more likely to pose naturally and give you plentiful expressions to work with. There's nothing more disappointing than forcing a child to cooperate and ending the session with too many forced smiles and pouty frowns. (Not to mention the stress your demands place on youngster and photographer alike!) You'd be surprised how quickly a session can turn around when you let go of your preconceived notions and let the joy of the moment command the session.

GO WITH THE FLOW

While it is always good to plan your session ahead of time, it's also prudent to keep versatility in mind. If your children just aren't on the same page as you are, either:

- Ask them what they would like to do, remaining open-minded to the opportunity to create some wonderful new memories, or

- Try again on a day when they are perhaps feeling a bit more up to it.

I AIN'T NO FAIRY
When no amount of cajoling will get the wings on, don't force the issue. A happy, smiling baby makes for a pleasant shoot and a gorgeous photo.

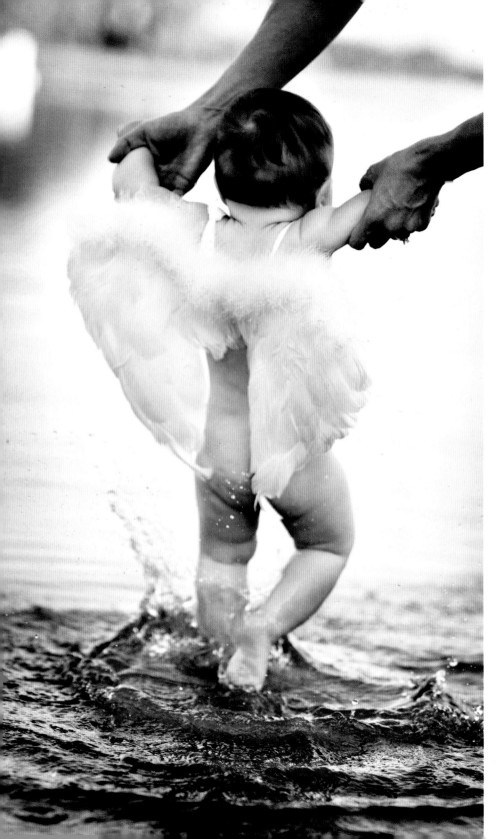

Keeping Your Cool and Keeping Things Fun

One of the best ways to get the photos you've always dreamed of is to ensure that your subjects are enjoying themselves.

While the type of fun that appeals to each child will differ, remembering to keep your session lighthearted and enjoyable will always help you produce images that capture this special time in your child's life. This is also a great opportunity to access your own inner child, remembering how you used to splash around in mud puddles after a rainstorm or catch fireflies at night.

Thinking with this mindset is a great way to begin brainstorming some concept possibilities for your shoot. Think about what your child likes to do or what he or she talks about most frequently. Do dinosaurs intrigue your son? Why not pick up an explorer outfit and see if your local children's museum will be featuring any new exhibits this month? If your little girl dreams of being a princess, why not let her dress up in a timeless outfit and try an outing to a nearby park with a medieval-themed playground?

BACK TO BASICS
A good splash around in shallow water is enough to get any water baby amenable to a quick photo shoot — but make sure the water's warm!

Don't Rise to It

Despite your best efforts of both time and money, your child may ultimately not be ready for a high-caliber shoot. When children are expressing strong negative feelings about posing for you, it's best to stay calm and keep yourself from fussing too much over it. A lot of times, kids put up resistance to activities in order to get the biggest reaction out of a parent. Showing them that it's no big deal to you if they don't cooperate will eventually make them grow tired of the ordeal. Soon they'll learn that enjoying the time with you is more fun than putting up a fight.

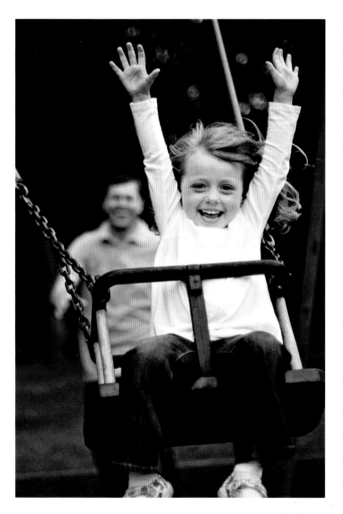

TRIED AND TESTED

Here are a few of my go-to favorites when it comes to themed shoots:

- Throwing on a pair of patterned rain boots and splashing around outside.

- A trip down to the beach for a day of collecting seashells and starfish.

- Grabbing some brightly colored balloons and taking a walk through a park.

The key is to find anything that will spark your child's interest in a new and exciting way, while simultaneously providing you with some amazing photographic opportunities. See Chapter 6, The Big Day, for more ideas.

PLAY IT COOL
Sometimes bears don't want to play ball. Avoid making too much of an issue of things and don't be tempted to try further bribery. Try another day, or just capture the emotion!

TRY THE FAMILIAR
Left: If it's good old-fashioned smiling faces you want to photograph, nothing beats the familiarity of the local park. In an environment your child knows and associates with fun, she's bound to relax. (Photo: Siobhan Murphy)

Age Groups

Taking the ages of the children you are photographing into account is just as important as decoding their personalities.

Over the next few pages we're going to discuss different age groups and the unique challenges that come with each. Think of the entire process as a precise recipe; you have to measure all the components — such as clothing, themes, settings and props — correctly, otherwise you'll risk jeopardizing the final product.

Newborns

In photography, a newborn is generally considered to be between 1 day and 6 weeks old. For parents, this is an exciting time filled with uncertainty and discovery. Here are some tips to help freeze time for long enough to capture some memorable shots:

- **Home comforts** Before preparing to take images of your new baby, remember he or she is more likely to be docile and happy when kept warm and with a full belly.
- **Catch them unawares** Sleeping babies usually photograph better because their eyes are unable to focus, which can make them appear crossed. You'll find that once sleeping soundly, newborns are easily moldable,

WINDOW OF OPPORTUNITY
When photographing a wide-awake newborn baby, make sure you're as prepared as you can be. Know where you're photographing, know what shots you want, check light levels and so on. (Photo: Siobhan Murphy)

FOCUS ON FEATURES
Above right: Almost everything about a newborn baby is cute and wondrously small. Don't feel you have to focus on the face all the time, though; shots of feet, hands, even ears, can speak volumes. (Photo: Pear Photography)

making it possible to get seemingly impossible shots.

- **Simple clothing** Dressing your baby in simple, plain-colored outfits will enhance the purity of your images. White babygrows and simple diaper covers are great options. Search online for handmade newborn hats to add a little style.
- **Classic poses** Place your baby on a large, soft surface (with at least one other adult to supervise). Once the baby is asleep, the classic pose of baby on belly with feet tucked underneath is the easiest to achieve. Other pose ideas include capturing the smallness of your baby's head in Daddy's hands and Mommy snuggling against the baby's cheek.
- **Baby's comfort comes first** Get creative with backdrops and poses, but not to the extent that you risk making your baby uncomfortable.
- **Don't forget the little things!** Close-up shots of the baby's feet and hands are always great to look back on and make great keepsake gifts for family and friends.

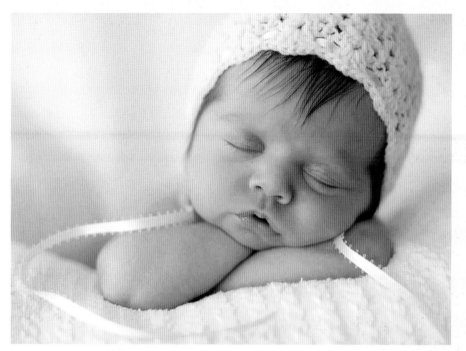

SOFTLY, SOFTLY
Top right: Gentle, diffuse lighting devoid of any shadows is best for baby shots, because it shows off the softness of the skin. If you have direct light coming through your nursery window, use a light, translucent material to soften the light.

SMOOTHING THINGS OVER
Your baby's skin may occasionally appear quite blotchy (although this is perfectly natural); a good way to get over this photographically is to either use your camera's black-and-white setting or convert color images to black-and-white later on a computer.

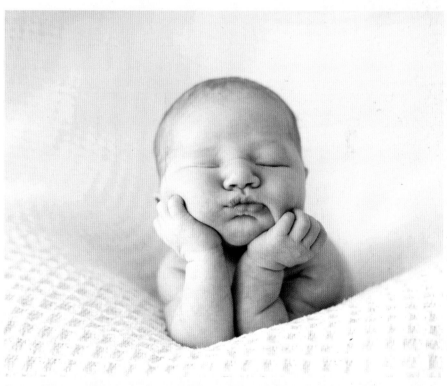

6 to 10 Months

Once your baby is able to sit up, the real fun begins. This is, by far, my favorite age. It's the time at which babies are always smiling and laughing. But never forget that they are still unstable on their new legs; therefore, keeping another adult on hand in case they topple over is always recommended.

At this age you can really go all out and have fun with your photo shoots. Your subjects can't run very far away, and they can't tell you "no," so break out the flowerpots, patterned shower caps and angel wings!

Here are some top shooting tips for this age group:

- **Be organized** Be sure to plan ahead and make your shoot time last no more than 10–15 minutes.
- **Limited wardrobe** Keep the number of outfits limited to one or two; this will help your model stay in a cooperative mood.
- **Provide some treats** While this age can be a lot of fun, they do tend to grow tired quickly. One trick is to keep a few favorite snacks in their lap to keep them sitting still while you snap away.
- **Keep bribery to a minimum** Holding a toy hostage will only make your child want it more and, in my experience, will result in the inclusion of the toy in the photos. Try making silly faces and animal sounds instead, which will add a little humor to the scene, giving you some really great, natural smiles to work with.
- **Stay in control** Avoid repeatedly calling the child's name, since this can be both confusing and overwhelming.
- **Distract your baby, not the viewer** If you find your baby needs something to focus on, try wooden blocks or toys with muted colors. This will add a little character to your photos without distracting the eye from the real subject.

CRYBABY

So we all want pictures of happy, smiling babies most of the time, but let's face it — babies cry, a lot. So the odd photo of junior in tears is not only representative, it can also be very cute.

THEY'RE ONLY THIS SIZE ONCE

At this size you can fit your baby into just about anything. Think of a fun and wacky (but safe) receptacle and find a complementary outfit. Choose a location with soft lighting and a good backdrop and shoot away.

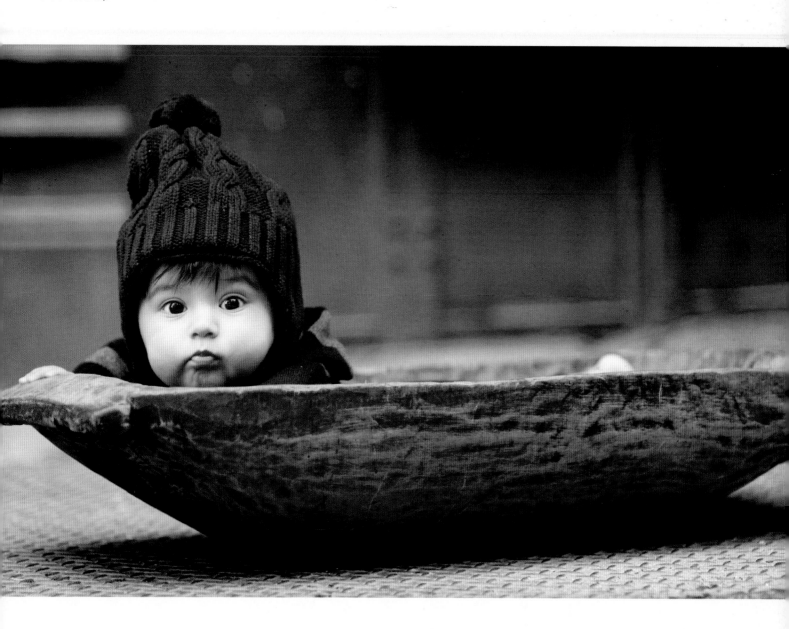

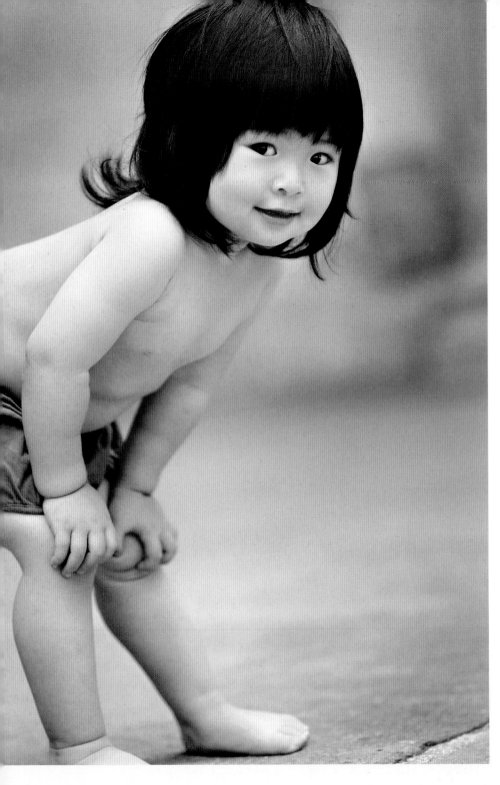

Toddlers

Toddlers are also a lot of fun to work with, but they're usually more tiring. Their budding personalities, strong opinions and boundless energy are sure to keep you on your toes and test your skills.

Using the tools we've discussed so far will be more important with toddlers than any other age group. If a toddler thinks your ideas or outfit choices are bad, they will have no problem telling you.

Top tips for photographing toddlers include:

■ **Keep your cool and think on your feet** Some of the best images come from shoots in which your children are allowed the freedom to express themselves and are given the chance to explore.

■ **Take cues from your toddler** Does he want to go off and try to catch that frog? Let him. Capture the wonder and excitement he experiences on his adventures. After all, you can always bathe him later.

■ **Look out for signs of fatigue** Remember, although toddlers have more energy than their younger siblings, they too can tire quickly. Stop the shoot before any tears or tantrums start; that way you'll find it easier to photograph another day.

ON THE LOOSE
Once they're mobile, children can become harder to photograph. If they've got bundles of energy, find a location where they can run around safely. Then simply follow them around and photograph their antics. Using a wide aperture will help to blur the background.

PROVOKING A REACTION

Take your toddler out on days when the weather's good, such as to the local city farm or animal sanctuary. The new sights, sounds and smells are bound to stir up curiosity and the odd look of amazement. (Photo: Allison Cottrill)

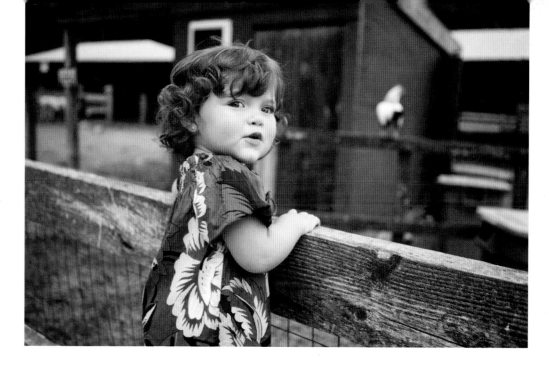

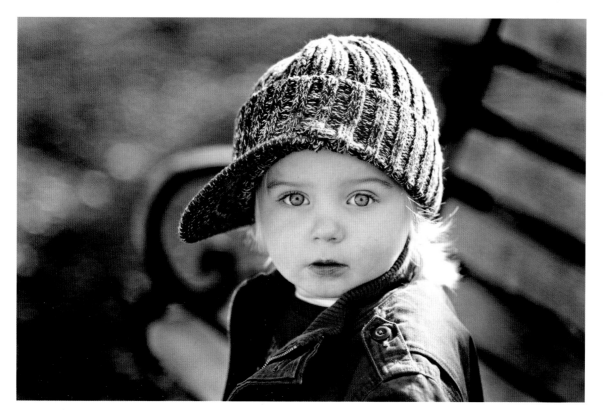

WHO SAID THAT?

When simply out and about with your young one, keep your camera out of view so that he doesn't suspect anything. Set a wide aperture, and when he's looking the other way, prefocus on the back of his head. Then call his name, and when he turns, capture the completely open, unselfconscious look on his face.

Children

The biggest and most varied group in terms of ages is children. Into everything and anything, they're most definitely on the move, pretty much constantly. But there are quieter moments of reflection, such as doing homework or watching a favorite movie, that lend themselves to portrait-style photography, so having your camera within reach and at the ready is a must if this is the type of image you want to capture.

Generally, though, you'll have more success acting as a reportage photographer, involving yourself in the action and snapping events as they happen. You might want to reconsider those repetitive requests to pose and say "cheese"—it's all about living in the moment, and drawing out the spontaneous reactions from within your child.

PICKING A FLOWER
Even though this is a posed shot to camera, during the shoot this little one was allowed to run free, and she hand-picked the perfect prop to help her pose.

FAMILY PET
The photographer of this shot might have been waiting a long time for all three subjects to face the lens, but, as the dynamic image shows, it would have been an unnecessary wait. (Photo: Amy Wenzel)

POSING PIRATE
Okay, so this is a posed shot, but the young pirate is certainly not saying "cheese," proving that an edgy mood can really work to enhance a theme. (Photo: Malin Lewrén)

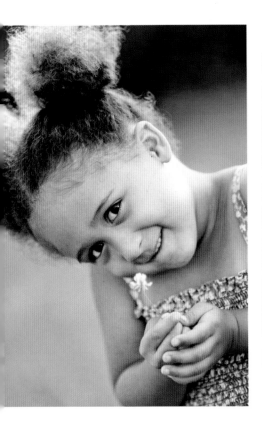

Try these pointers for photographing children:

- **Get out and about** Location shoots will work particularly well with kids, helping to set a theme while allowing them to release all that energy and go wild.
- **Let them choose props** At this stage of life they're developing a keen sense of what they like and don't like, so let them decide which toys they want to bring to a shoot. Whatever they choose, it will speak volumes about their personality and interests at this time.
- **Friends and family** Discovering their character through interaction with peers and siblings is the cornerstone of growing up, and

what better way to record the process than with your camera. Invite their closest buddies round for a play session, letting the parents know your plans, or put siblings in the same location and watch the fun unfold.

- **Take on a different role** Become either a quiet observer — waiting until they have forgotten your presence and then snapping away from the sidelines — or a fun playmate: wearing your camera around your neck, joining in the action and shooting intermittently, without being too fussed about the angles from which you are shooting.

FOREVER FRIENDS
The familiar faces of childhood friends not only give context to your images, placing them at a certain period in your child's life, but also evoke strong memories when your child has grown into an adult and revisits the cherished images.

Preteens and Teenagers

Preteens and teenagers, like toddlers, can often be difficult to photograph. They are constantly testing their boundaries and trying to exert their individuality.

One of the most important factors when working with this age group is to plan your session with them, not for them. You will find that they feel the need to be the director of the planning committee instead of just part of the cast. Asking their opinions about a shoot is always a better tactic than simply blindsiding them with your plans minutes before you start shooting.

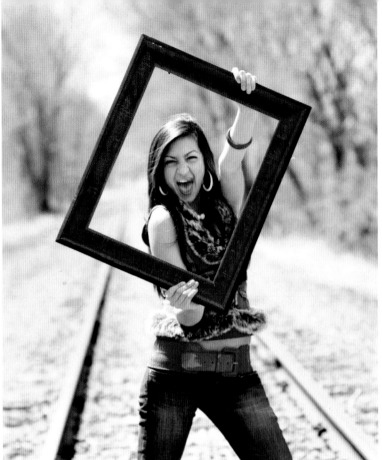

These are some of my favorite preteen and teenager shoot tips:

■ **Be flexible and keep your mind open to their attitude** If they want to wear concert Ts and skinny jeans, let them. If they refuse to get a haircut before the shoot, take a deep breath and refocus your attention on another aspect. As much as you'd love for others to view your family as a neat and happy unit, sometimes the reality of the situation takes precedence over your ideals. Instead, make their funky wardrobes and tousled hair work to your advantage. First talk to your teen and find out what they are and aren't willing to wear; this will give you a baseline from which to work.

HAVE A BLAST!
You may be surprised to find that your teenage subject is full of creative ideas for her shoot. If so, fantastic! Work together at coming up with some shots and poses — and just have fun.

THEIR CHOICE
Left: Don't try to impose your fashion sense on your teenagers if you want a successful shoot. Let them choose the clothes they want to be seen in and the location.

- **Have fun with dress up** If you're lucky enough to be blessed with a teen who will allow you to play dress up for your dream shoot, then the sky is the limit. Together you can dream up some amazing options for both clothing and location — consider taking inspiration from her favorite movie or his favorite music video — and with the cooperation you receive, you'll be able to pull off some truly amazing images!
- **Brainstorm location ideas** Try to come up with a few choices that work nicely with the outfits you and your teen have put together to avoid a disconnected look in your images. If your son or daughter is partial to a particular brand of clothing, take a peek at their catalogs to see what types of locations they use to showcase their own clothing.

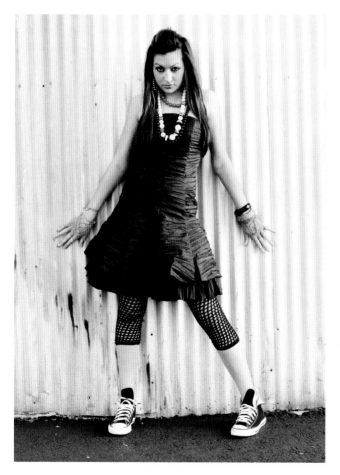

RESEARCH TOGETHER

Left: Look through magazines or online with your teenager for inspiration. You'll learn a lot about what she likes in terms of clothes, styling and mood. It's a good way to make sure you have common ground before getting the camera out.

GET WALKING

Often the hardest thing about photographing people — of any age — is finding the right pose. If you're stuck for ideas, get your subject to move around, walk toward you or in front of you, turning to you as she passes by. Use your camera's continuous shooting mode to capture several frames in quick succession and see which looks best.

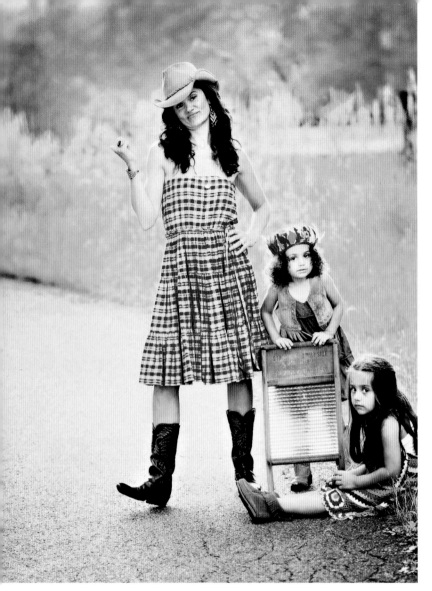

Group Shots

When it comes to group shots, particularly children-only groups, let's face it — you're going to have your work cut out for you.

Group shots are very daunting for the average home photographer. Even when you have your group more or less in the right place, the next obstacle is getting everyone to simultaneously look at the camera and smile. To tackle this endeavor, you will need a surefire game plan.

Firstly, communicate: Have a talk with all of the older children and the adults who will be included in the shot. It is important that they, as the most cooperative members, continue looking and smiling at the camera, not coax the other children to do the same. Having a portion of the group already attentive will make your workload a little lighter, and it will also set an example that the youngsters will hopefully mimic.

Secondly, seek assistance: Ask a friend to be a dutiful helper. Have your friend stand off to the side of your group, slipping into the shot when needed to quickly remove fingers from mouths or to catch and return a runaway on the loose. Gently tell this friend to shy away from eliciting smiles and giving directions to the group. Too many people giving directions at the same time will only cause confusion and chaos and will eventually end in heads turned in all directions. If available, direct another helper to act as the stand-in clown for the shot. Pick this friend wisely and beforehand, as a characteristically comic friend will fare better at the job.

Strike a Pose

Posing groups can be tricky, but there are some key points to remember that will give your image a professional look:

- Elder members should always take center stage, because they are the backbone of your family. If young enough, place the youngest children on the elders' laps or in their arms. From there, fill in the gaps around them with the rest of the children and adults.
- Take some creative license with placement at this point, and don't be afraid to try a few different configurations to get the best results.

FOLLOW THE LEADER
Ensure any adults in a group shot involving children are fully engaged with the photographic process. Make sure they take the lead, get into character and show the youngsters how it's done. The little ones are likely to follow suit.

BE DISCREET
Top right: The best time to take group shots is during birthdays and other celebrations. Quietly go around taking shots as the party games are in progress in order to capture the action as it happens. You might just go unnoticed, by most anyway!

- Ultimately, you should always try to form a stacking triangle with your subjects; this will give the best presentation overall.

Clothing Considerations

Color coordinating everyone for a group shot is just as important as having everyone looking toward the lens. Matching tones is a great place to start, but be careful to avoid any uniform looks. By all means keep the same color present throughout several outfits, but try to incorporate different shades and tones to add a little definition. Although tan slacks and white button-down shirts are classic photo-shoot outfits, remember to embrace your family's quirky side and let them show how unique and special they are. Finally, consider where your portrait will be hung in the house. If the main hues in the room are blue and chocolate, try incorporating these colors into your images.

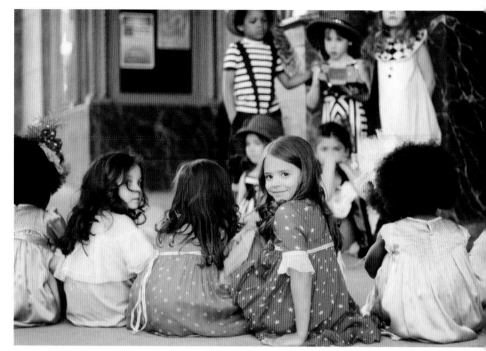

SIBLING SHOTS

Shoots involving brothers and sisters, especially if relatively young, are always unpredictable. Try soliciting a few helpers to help maintain a calm environment and reduce stress levels. The best way to keep your children still while also adding a professional touch is to include some props. During the holidays, have your children bake cookies together with you. This is a wonderful way to include them in a special activity while observing them interacting in a fun and unique way. Alternatively, try to capture them cuddling in bed, playing in a fort or doing any other activity that they typically enjoy doing together. When considering siblings of varying ages, such as a newborn and a toddler, wait for the younger one to fall asleep before posing them. Once one child is under control, try having your toddler lightly kiss the baby's forehead, touch the baby's back gently or just stand behind the infant and smile up at you. These can make for unforgettable images.

When photographing brothers and sisters, it's essential that both are equally at home with what they're wearing and the location, if away from home. When they're confident in themselves it shows. Tell them if they work together as a team, there's a treat in store. The odd bit of bribery can go a long way!

CHAPTER 5

Location, Location, Location

Think of your choice of location like choosing the right pair of shoes. If you spent an eternity picking out the perfect dress for the most important event of the year, why just throw on a pair of old running shoes? You'd be surprised at how often people get caught up in the design elements of a shoot and overlook the most obvious details. Your subject may be dressed and styled to the nines, but nobody looks good in a cluttered kitchen with a sink full of dirty dishes — so let's go exploring.
(Photo: Helen Rae)

Make the Most of the Weather

As a keen photographer you're likely to work in a variety of weather conditions, from clear, unbroken sunny days through misty, slate-gray days to rain and possibly even snow.

All types of weather will have an impact on your photography, primarily because atmospheric conditions determine how natural light behaves, and, as we know, light quality more than just about anything else affects the mood of our photographs. However, it's not just about how weather affects the look of photographs, there are practical considerations to take into account as well.

WILD AT HEART
Stormy, windy conditions can make for dramatic images with glowering gray skies, and kids often love to be out and about in high winds. (Photo: Steve Luck)

Wet and Windy

How many times have you woken up to a gray, rainy day and thought it's not a day for photography? We all have. And, of course, if you were a professional photographer with a specific shoot to fulfill you'd probably think "studio." But don't dismiss such weather too quickly. Sure, if it's a constant downpour then it's probably best to wait until it eases up a little (and definitely if there's lightning around!), but if it's more squally and showery, get everyone into their colorful wet-weather gear and head out.

This type of dramatic weather can provide dramatic-looking images. Often, following a storm, you'll get dark, threatening clouds interspersed with bright rays of sunshine, which creates a striking contrasting backdrop to any photo. The trick is to keep a close watch on the clouds, the direction they're moving in, where they're thinning out and the relative position of the sun and your subjects. Don't expect your children to hang around waiting for the right light; simply let them get on with playing their games, chasing the dog, riding their bikes and so on, while you keep a close eye on the clouds above.

KEEPING DRY

In wet conditions it's all about keeping everything dry — that goes for children as well as equipment. If the children get cold they're not going to want to hang around for long, and if your equipment gets too wet it'll stop working. If you have a camera bag, make sure it's waterproof and that everything inside stays dry. When walking around with a view to grab a shot or two, it's important to ensure that you don't get spots of rain on the lens, since these are liable to show up in the photos. Keep the lens cap on until the last minute, and if it suddenly gets wet again, keep a plastic bag handy into which you can quickly put your camera, without having to open up your camera bag and run the risk of soaking its contents.

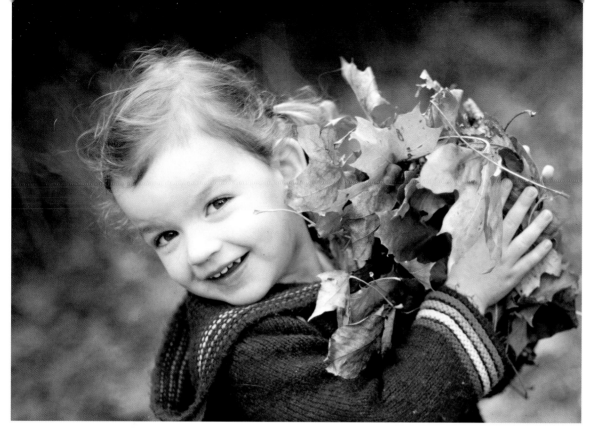

Misty and Gray

Although gray, misty weather doesn't inspire at first, such conditions can create soft, romantic portraits. Light will be diffuse and gentle, ideal for softening and smoothing skin, and for shadow-free features. When the light quality is diffuse, don't attempt to brighten images with loud, colorful clothes: choose pastels, creams and whites to complement the conditions, and look for a plain, natural-looking backdrop. As is often the case with portraits, the best technique is to use the widest aperture to throw the background out of focus. This works well with all portraits, but in misty conditions the blurring helps to emphasize the soft nature of the light.

Black-and-White

Misty weather is a good time to try to create some black-and-white images, since such conditions lend themselves well to a monochromatic treatment. If you like to edit your images, don't use the black-and-white setting on your camera, because this will restrict the level of adjustments you can make to the brightness and contrast settings.

Instead, shoot using the raw setting if you have the option — shooting raw will provide you with the best image quality when editing images. This goes for color as well as black-and-white.

Equipment and Settings

To capture a moody, stormy setting, you'll want a wide-angle lens or zoom setting, somewhere between effective focal length of 25–40 mm (1–1½ inches). You want to make sure you can get as much of the stormy sky in as possible. Naturally, with these settings you won't end up with close-ups of the children, but the intention is to put them in the context of the dramatic landscape. It's also likely to be dark, so you may want to increase the ISO setting to 400, 800 or even higher (as long as this doesn't produce too much noise with your camera). Increasing the ISO will let you set an aperture that should keep most of the scene in focus (around $f/8$ or $f/11$) while still using a fast enough shutter speed to freeze all but the fastest movement (say 1/125 second). Then it's a case of waiting for the right light.

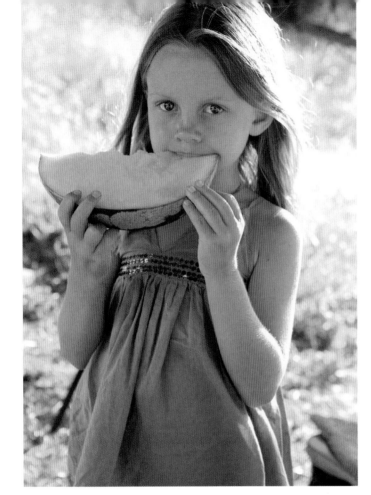

Fun in the Sun

Everyone feels better in warm sunshine, and it's a pleasure to photograph when everyone's upbeat and invigorated. Bright, clear sunlight is great for showing off bright colors, so in these conditions look to pack your images with lots of colorful clothes, props and backgrounds.

If you're blessed with long, hot summers, try to photograph early in the morning and later in the afternoon, when the sun is not high in the sky. At these times the light is softer and easier for photographers to handle, because there's less contrast to deal with and fewer short, dark shadows that can spoil people's facial features. Experiment with placing your subject in different positions relative to the sun. The rule of thumb used to be shoot with the sun behind you, and while this is good advice, since it produces less contrast, your subjects can end up squinting. Shoot with the sun to one side or even behind your subjects for greater impact — with care you should get some nice glowing effects, but avoid too much of the image overexposing.

With good light levels you can really experiment with aperture and shutter speed settings. Vary the aperture for short and wide depth of field effects and shoot your subjects at different angles — get down low and climb up high. Avoid always shooting from shoulder height in a standing position to add variety to your images. Also vary the focal length. Get in close for face-only shots, and move back and shoot wide-angle to capture your beautiful sun-kissed surroundings.

RADIATING HEAT
Summer sun is great for capturing young, healthy skin. If you shoot with the sun behind the subject and off to one side, you should be able to get images like these, with a bright, light atmosphere and soft textures that glow. (Photos: Nina W. Melton)

SNOW AND SAND

When photographing on the beach or in a snowy landscape in bright, clear conditions, your camera can get fooled into underexposing the scene, because the light is reflected off the pale snow or sand, resulting in murky looking images. Many cameras have a "beach" or "snow" setting that will take this into account and automatically increase the exposure; by all means use this setting if your camera has one. If not, use the exposure compensation (EV) control to increase the exposure so that the snow or sand comes out clear and bright.

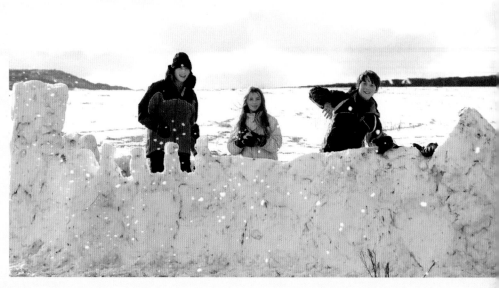

ROSE-TINTED LENS
Below: Shooting at the end of a clear summer's day produces images with a magical, soft, rosy cast. Skin appears to glow, and shadows are long and soft, adding to the atmosphere of the image. (Photo: Steve Luck)

WHITE AS SNOW
You may find that your camera overcompensates for bright, snowy conditions and underexposes, resulting in dull-looking snow. Increase the exposure to capture bright white snow. (Photo: Steve Luck)

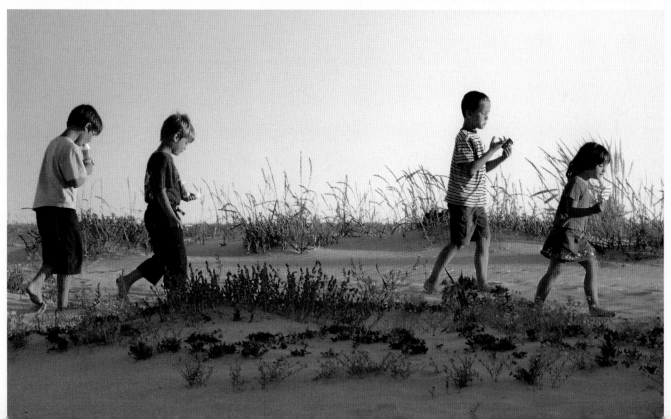

What to Look For

Whether you're in the market for the idyllic country field or a "hip" downtown street, finding a location and theme can be as easy as taking a relaxing Sunday drive.

Whenever you're out and about, it pays to always be on the lookout for locations — it also pays to have a notebook on hand to keep a record of the locations. In terms of urban areas, it's important that your potential locations are free of garbage and any other objects that may distract the viewer from your subject.

Time of Day

It's also important to scout possible locations at the same time that you'd most likely be there when actually shooting. You may find that what looked to be a perfect field at noon is actually a dull, flat, lifeless area at sunset because the beautiful rosy light is blocked out by a row of houses.

Also watch out for anything in your location that reveals your secrets and erodes the credibility of the image. For example, is that wildflower patch really just a small area of flowers next to a large industrial building? In which case,

make sure that you can angle the camera to avoid revealing anything other than a rolling field of wildflowers. A camera can be your best friend if wielded correctly in order to show only what you want the viewer to see.

Think Laterally

We can all agree that while a field of flowers makes a perfect background for some children, for others you may need to get a little more creative if you want to spark some true reactions. You may find that an old car scrap yard fits perfectly with your son's "grunge" style. Regardless of your location, the same rules apply. However, in the previous example, make sure you avoid capturing visual hints that will let on to others the fact that the "scrap yard" is really just a few old cars in the driveway. Again, play with the camera angle so that all that the viewer sees is what you intended. Remember, imagination starts with inspiration.

If you have kept a scrapbook of clippings and images you admire, study the backgrounds and try to find similar locations for your shoot. The only thing to keep in mind is to have the proper authorization or permission, if need be, to use the locations you have in mind before shooting, especially when working with small children.

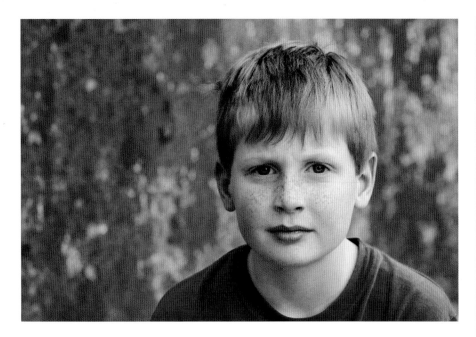

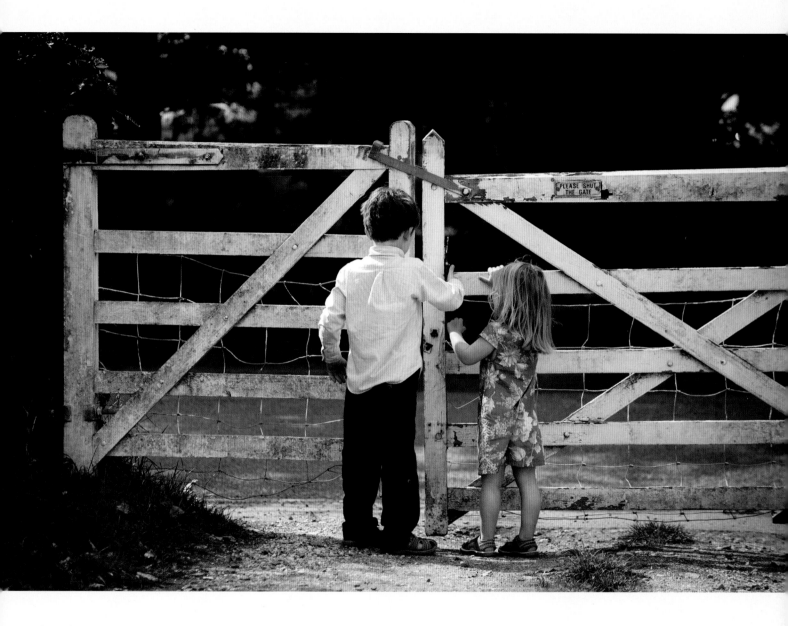

SUIT YOUR SUBJECT
Far left: Your location doesn't always have to fit the dreamy, rural idyll stereotype; you may find that your subject responds better to rundown industrial, or that the rusty backdrop reflects those sweet freckles. There's no right or wrong. (Photo: Helen Rae)

WOODLAND WONDERLAND
Left: Few settings are more romantic than a woodland path scattered either side with spring bluebells — an ideal location for a portrait. If you have a particular location in mind, think about the timing of seasonal wildflowers since they can be quite short-lived. (Photo: Jess Morgan)

PLEASE SHUT THE GATE
Family walks usually provide plenty of occasions for charming portraits like this one. With other things to keep them occupied on a walk, children will soon forget about the camera, and you can capture lovely natural images. (Photo: Helen Rae)

Be Prepared

Making sure your family shoots go off without a hitch will require a lot of organization on your part — here's how to stay organized.

When it comes to family photo shoots, use what you can to keep everything on track. Get into the habit of using your smartphone, a notepad or even creating a computer spreadsheet of checklists to keep the chaos to a minimum. Always make sure your camera is ready to grab at a moment's notice and tucked safely in your bag. (You may be surprised at how easy it is to grab your bag and leave your equipment sitting on the kitchen counter.) Always keep your batteries charged and have a few extra memory cards handy. This will cut down on the last-minute preparation when the mood strikes you and a wonderful late afternoon sky is taking shape.

Think Ahead

When dealing with little ones (and not so little ones), you will need to make sure you have plenty of snacks and drinks, as well as a fresh change of clothing, some baby wipes, a hairbrush and a favorite toy or two. Having a few tricks up your sleeve, such as a container of bubbles to keep squirming children interested, is also highly recommended.

Leave your prized outfits safe on the hangers until you are ready to head off to the location; this will ensure your items stay freshly pressed and look as well put together as possible. Some parents like to keep outfits on the hangers even during the journey to the location. This is fine, and certainly means your children will be looking their best, but just make sure you know there's somewhere for them to change when you get there.

A word to the wise — tackle the hair fussing and face cleaning well in advance of your shoot. You don't want unhappy campers and pouty faces littering your images.

DOWN TO THE LAST DETAIL
Opposite: It often pays to leave nothing to chance. The location, the outfit and even the time of day and the colors of the balloons were meticulously thought through and planned to arrive at this airy woodland image. (Photo: Jess Morgan)

Plan B

The day before you're set to shoot, take a ride to your location, if you're using one, to make sure it's as you remember and hasn't suddenly turned into a construction site. Do some minor tidying up if you need to in order to showcase the best possible features it has to offer. It has been my experience many times that a location I frequent has been out of bounds for weeks, and I've had to move the entire shoot to another less favorable spot. For this reason and many others, always have a backup plan! Though we certainly try to, we can't plan for everything, and your dream shoot may have to undergo some last-minute modifications. Ensuring you have a backup for equipment, outfits and locations will guarantee a successful shoot.

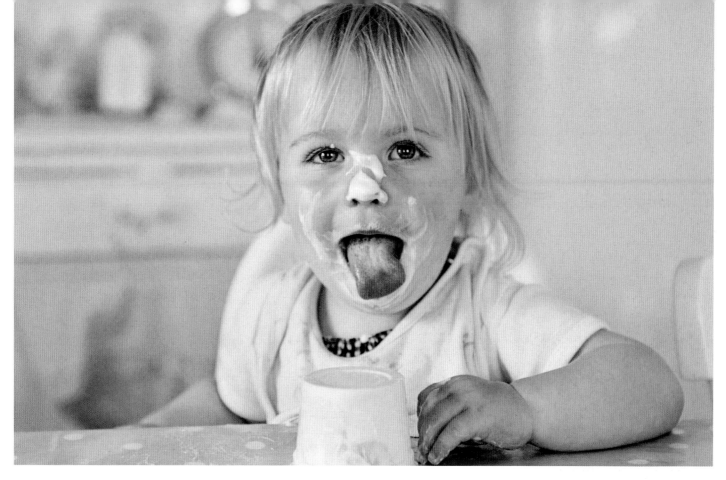

ORGANIZATION CHECKLIST

Here's a checklist that I often rely on. Your own helpful organization list may look similar to this one, but make sure the information is pertinent to your individual needs.

- Check all equipment: batteries, memory cards, lenses and bag.

- Remember any extras: diaper bag, change of clothes, hairbrushes, snacks, drinks and toys.

- Have all props packed and ready to go.

- Check outfits for wrinkles and stains; make sure all accessories and shoes are collected together.

- If possible, visit the location the day before, making sure it is still available and free from trash and debris.

- Make sure there's gas in the car or you have the relevant transit tickets.

These items are just a few basic suggestions. However, you want to make sure to tailor your checklist to suit both your and your child's needs. Most importantly, if you need a helper, make sure in advance that everyone is available at meeting times so that your light does not change while waiting for helpers who may be running behind.

GRAB IT WHILE YOU CAN
However much you might like to plan your shoots, don't forget that there will also be unrehearsed, impromptu moments that you'll want to capture. Make sure you always have some form of camera on hand, even if it's just a camera phone. With such devices nowadays there's no excuse for missing the unmissable. (Photo: Jess Morgan)

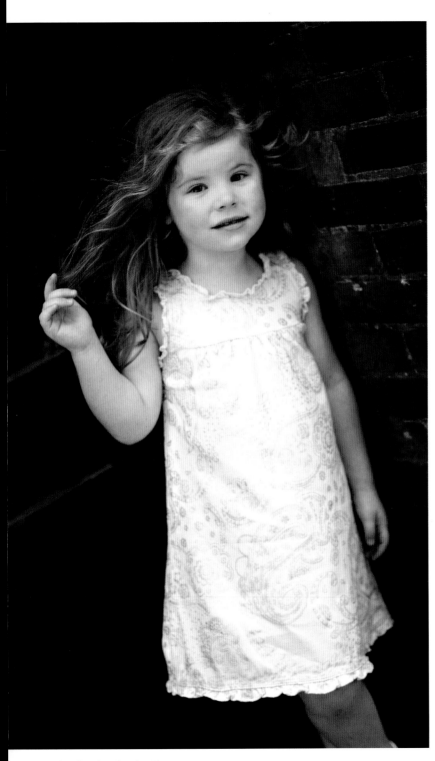

It's Not Always Skin Deep

There's more to locations than clapboard houses and flower-strewn meadows or the glitter and glass of downtown — don't dismiss areas that initially look like no-hopers.

You've heard the phrase "opposites attract," well the same can be said of photography. Using contrasting ideas within the same image is a powerful way to send a message and create more challenging portraits. The next time you come across a run-down part of the city, try to look beyond the deterioration and find the potential in old buildings. Even in old industrial areas, the brick faces and stone walls are beautiful if only for history's sake.

Texture and Atmosphere

Most of the time, the older facades don't appear in modern construction, and these textures can add a very rich element to your final images. Old houses with worn paint and wooden porches, mixed with the right props and cute outfits, can add the perfect shabby-chic element and really make your subject stand out. Of course, these things will require some thought and a lot of imagination, but many of the best images do! If the buildings are inaccessible to the public, you'll have to seek permission from someone who can give you access and reassure you that the structures are safe for your purposes. It may not always be possible to get permission, but when you do, you'll be guaranteed some original images.

Old factories and industrial sites can also make for ideal alternative locations. Again, look for textures, such as rusting pipes and peeling paint, that provide a perfect visual counterbalance to your young subjects in their soft, light clothing. Seek permission if the area is fenced off.

I always tell my clients that I don't believe in ugly people; everyone has something about them that makes them beautiful. For me, the same holds true for old buildings. Pairing them with the perfect baby or toddler can lead to some striking imagery.

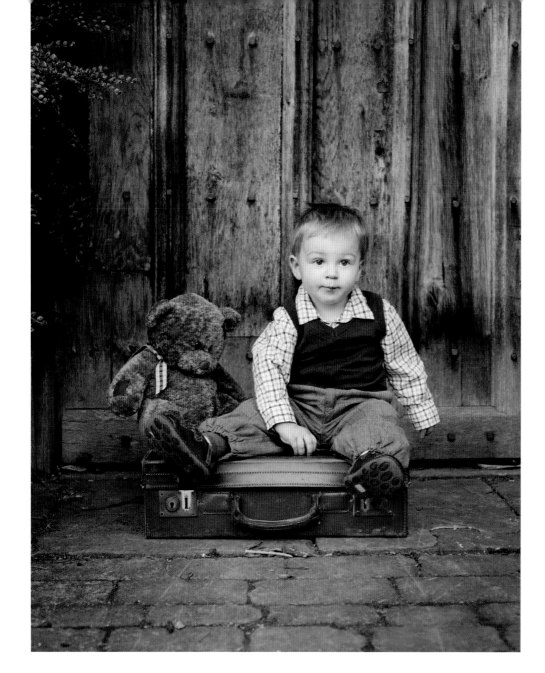

BRICK BY BRICK
Opposite: If you live in a city or town, look out for the older neighborhoods, since these often provide fascinating historic locations that offer a different mood than the steel, concrete and glass of modern buildings or the rolling fields of the country.

WORK ON-THEME
If you find an ideal location that just exudes atmosphere and charm, work on building a theme or storyboard to make the most of it. The textures, tones and props all pull together so well here and help to reinforce the strong underlying narrative. (Photo: Aneta & Tom Gancarz)

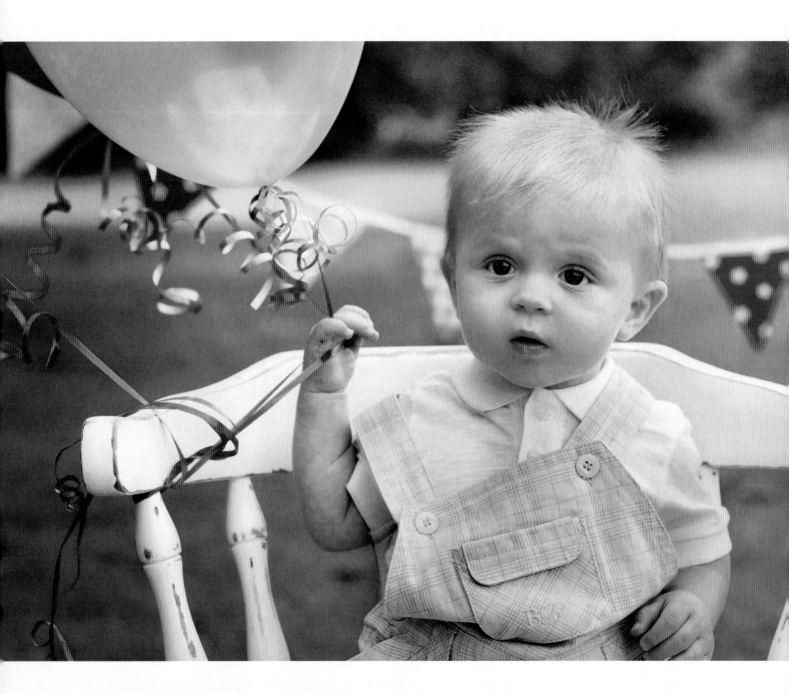

CHAPTER 6
The Big Day

It's finally here — the day of the shoot. This is the moment when all of your preparation, planning and studying will finally pay off. This section walks you through several scenarios and provides you with key technical information to help you recreate a similar look. But don't be afraid to come up with your own ideas. Over time the shooting process will become second nature, allowing you to think more creatively, ultimately developing yourself into a more seasoned photographer. As long as you had fun with your children and created some amazing memories, you have achieved your ultimate goal.
(Photo: Aneta & Tom Gancarz)

Down on the Ranch

A trip out to a ranch or working farm can bring you not only a file full of great photos, but a fun day out too. From a photographer's point of view, farming landscapes and agricultural equipment provide a lot of opportunities, not least their sublimely weathered condition, offering all kinds of interesting textures and backdrops. Kids will be at their best on a fun daytrip, and if they can go look at animals, such as horses, so much the better. You will be able to catch them being themselves and having fun in and around any plans you have for more formally posed shots.

BECOME A SPY
Try to be as unobtrusive as you can as your children go about the serious business of exploring. Using a long telephoto lens or setting (around 15–200 mm) will help you get close to the action without them noticing. Don't become obsessed by capturing their faces — a good composition and interesting action can make the picture.

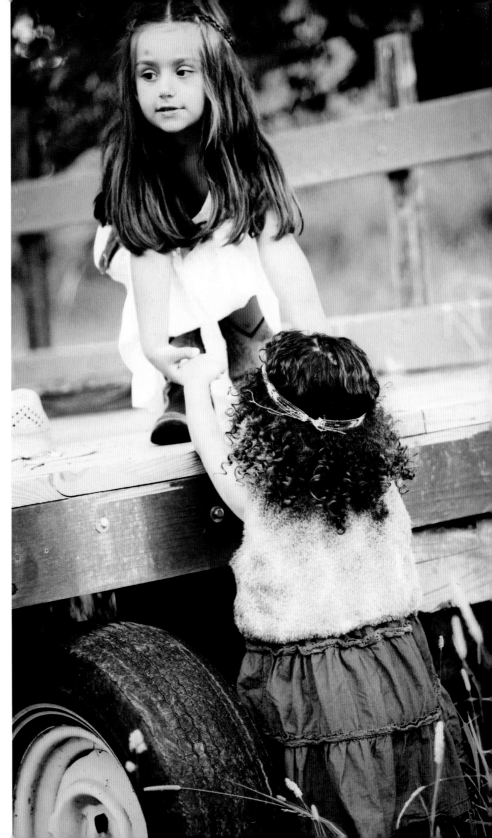

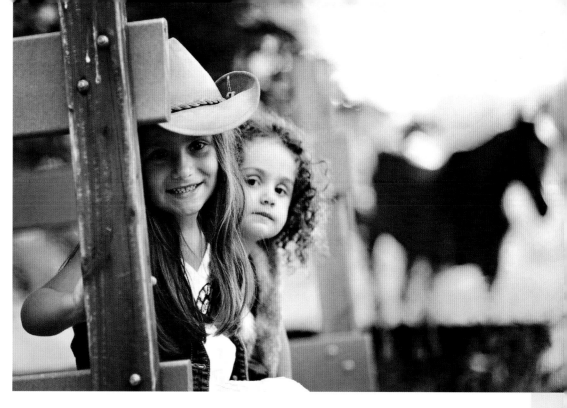

TO RECREATE THIS SHOOT
try the following:

Capture movement: Use the children's interaction with each other and any animals to show movement and bring more life to your images.

. .

Wait until sundown: Hold your session about 30 minutes before sunset, when the sun is nice and low. This will create a soft, glowing light. If you own one, have your reflector handy.

. .

Costume ideas: For girls, a cute dress, boots and hat will work effortlessly. For boys, experiment with jeans, boots, a vintage tee and a hat.

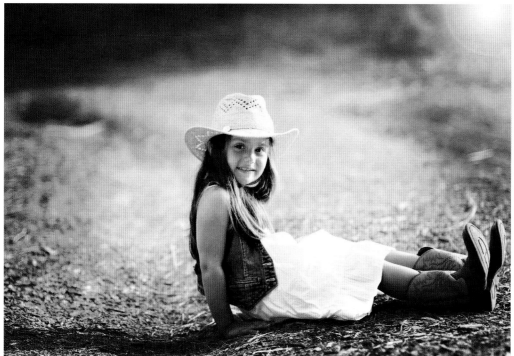

FINDING FRAMES
Remember to use whatever is on hand to frame your portraits. The upright of this trailer frames the girls' faces and helps to reinforce the theme of the shoot.

Technical information

Aperture	**f/2.5**
ISO	**200**
Shutter speed	**1/125**
Lens	**50 mm f/1.4**

NATURAL LINES
Locate a rustic dirt path and take note of how the lines in the path curve to one side or the other in the background. This is a great leading line and will add more drama than a straight walkway.

A Little Pop of Fun

When dealing with a child with a little too much energy, try to get him or her engaged in your fun by creating a rain shower with popcorn. Having a friend off to the side of the shot on a ladder with buckets full of popcorn would be a big help on the day. A bright, patterned umbrella adds an explosion of color and offers an array of compositional variations — use the prop to frame your subject. The key to this shoot: bags of unbuttered popcorn, to keep the mess to a minimum!

TELL THE STORY
Don't always focus on the children as your subjects. Look around for objects that reveal the theme of the shoot and can make alternative artistic shots when putting together a photobook, slideshow or multi-aperture frame.

VARYING THE CROP
It's important to vary your shots by zooming in and out. Make sure you have some full-length shots as well as head and shoulders. And remember to shoot at different heights and angles.

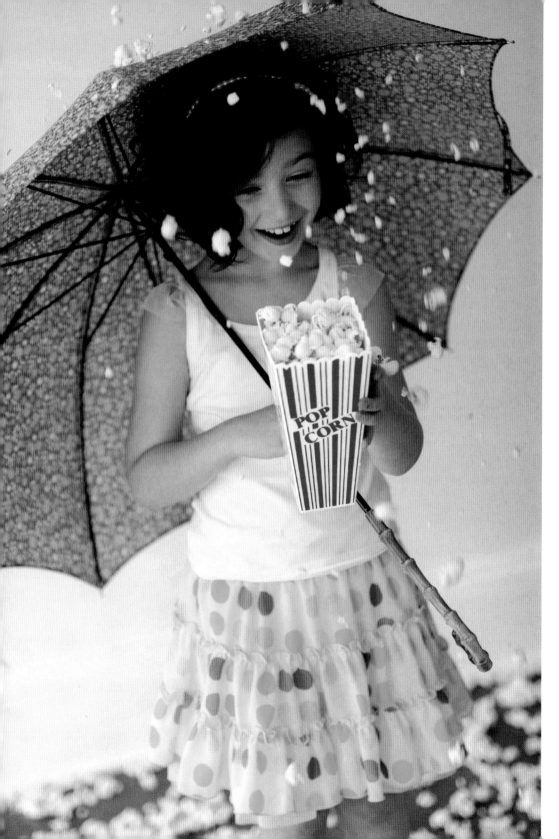

Fun and bright: Make sure the clothing is eye-catching and bright to reflect the fun of the shoot and contrast with the neutral-colored popcorn.

. .

Gather your props: Apart from the obvious — the popcorn — you'll need an umbrella (as with the clothing, bright and/or patterned is best), a container, a ladder for shooting from above and a dustpan and brush for tidying up.

. .

Neutral and simple: Shoot this scene indoors on a hard-floor surface, for easy tidying up. A neutral background will leave the clothes, umbrella and your child in the spotlight.

. .

Technical information

Aperture	**f/1.8**
ISO	**200**
Shutter speed	**1/250**
Lens	**85 mm f/1.8**

A Sleepover Like None Other

This idea works very well with older children. This pillow shoot can be done both in and outdoors, but the cleanup indoors will be quite extensive! Taking this adventure outside will create a contradictory twist that will leave the viewer in awe. This can be done with either a pre-purchased bag of feathers or by cutting a small hole in each feather pillow and really letting your kids go at it. If you decide to carry a bed into a field, this shoot will most likely require that a few other adults be present. With enough people willing to participate, this shoot is well worth it!

QUIETER MOMENTS
When there has been a lot of action but then things slow down, many people will simply put down the camera — don't! Keep capturing shots of the aftermath, since these offer a different mood.

FROM ALL ANGLES
When shooting outside, don't be afraid to experiment. Shoot into the sun and let corners of the image overexpose. Don't be afraid of lens flare, just try everything. Shooting digitally doesn't use up film, so fire away!

TO RECREATE THIS SHOOT
try the following:

Colorful contrasts:
Suited to a group sibling or friends shoot, this is an ideal opportunity to coordinate some colorful clothing.

Alternative feathers:
The feathers are the key to this shoot because of the way they swirl in the air. If your child has allergies, try using bags of confetti or pieces of sparkling Christmas tinsel instead.

Take it outside: Ideally this is an outdoor location shoot, not only due to the mess, but also because you want the kids to go wild — they will feel less inhibited outdoors.

Technical information

Aperture	f/1.8
ISO	250
Shutter speed	1/1000
Lens	50 mm f/1.4

Apples to Apples

A well-covered, open shaded area in front of a vintage pickup truck sets the scene for this countrified shoot. Apple baskets can be sourced from craft stores, farms or even a local garage sale (as this one was). The amount of apples is somewhat deceptive. While you could fill the entire container with apples, why not save some money by first putting a blanket in the bottom of the container and then placing a layer or two of apples on top. Take a few bites of the apples and place them randomly around your child, completing the apple theme. For boys, a sweet denim overall set and bare feet underline the country style. A similar theme and styling would work just as well for a little girl, perhaps adding a cute newsboy cap or straw farmer's hat.

FOCUS ON THE SMALLER PICTURE
When scouting for locations to photograph this type of shoot, it's important to remember that the viewer can only see what's in the frame. These images look as if they've been taken in the middle of nowhere, but for all we know the young farmer could be in a built-up urban backyard. It's a hard trick to learn, but as a photographer you need to train yourself to forget about what's outside the field of view.

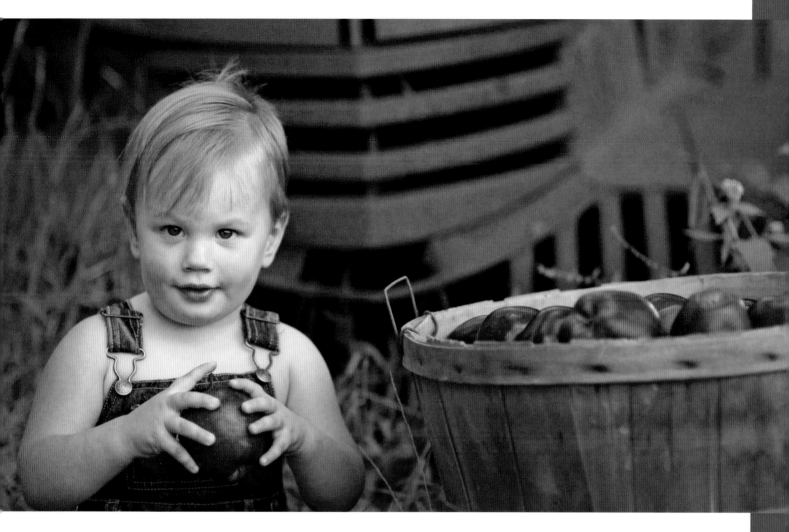

TO RECREATE THIS SHOOT
try the following:

Countryside tour:
Try to find a field or wooded area with access to an old truck or disused farming equipment (make sure the area is safe for your child). Failing that, go straight to the source and find yourself an apple tree.

Controlled lighting:
Choosing an area in open shade, for example underneath trees, should ensure that the lighting is consistent for the duration of your shoot.

Props to source:
Sticking with the apple theme, you will obviously need the apples themselves and a basket or crate. A blanket for filling the basket or crate and denim overalls complete the look.

Technical information	
Aperture	**f/1.4**
ISO	**200**
Shutter speed	**1/640**
Lens	**50 mm f/1.4**

It's Your Birthday!

Birthday parties are great fun, and there are no better occasions to capture some timeless moments. Many children like to celebrate their birthdays by dressing up — so ask your child what theme he or she would like to have for the party. Fairy tales or fantasy novels, such as *Alice in Wonderland*, are often great starting points, featuring lots of diverse characters that the children can choose from.

When photographing such an event, pay attention to detail, such as the place settings and party favors. When you've taken such care and love to make your child's special day so perfect, you really don't want to leave anything out. Action shots also work incredibly well, as seen here, and capture the spirit of the day. (Photos: Tamra Hyde)

WHO'S WHO
Try to photograph the guests individually as well as in groups, since this provides visual variety and important mementos later in life.

TO RECREATE THIS SHOOT
try the following:

Location and lighting: This can be done in any indoor or outdoor location, although open shade will provide light that's easy to work in and give you natural-looking results.

Unleash your creativity: Set your perfectionist tendencies to the side and try your hand at cake decorating and face painting. No matter your experience or creative ability, the kids will love your involvement, and you may be surprised at just how easy they are to please!

Technical information

Aperture	**f/1.4**
ISO	**100**
Shutter speed	**1/640**
Lens	**50 mm f/1.4**

THE BIG AND THE SMALL
Focus on the main events of the party, such as the blowing out of the candles, for your key shots, but don't forget to capture the details of the party, such as the decorations and tableware.

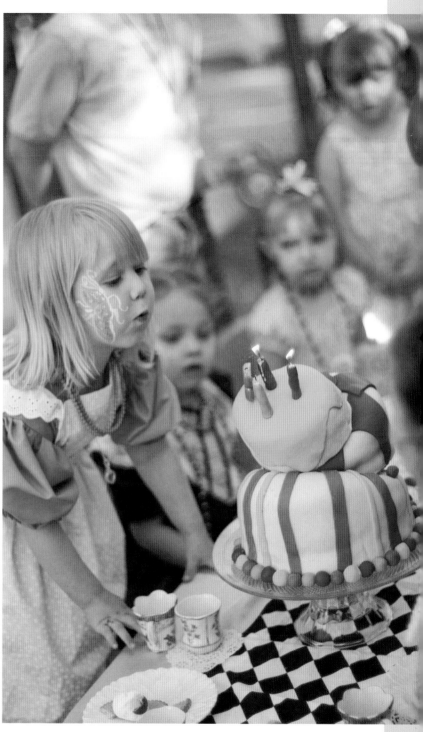

Costume ideas: *Alice in Wonderland* is a classic that offers plenty of fun for boys' and girls' dress up. Look to other children's books or movies for alternative themes.

Nature and Nurture

What a great way to spend a lazy, warm spring day — pottering around the garden with your children lending a helping hand. Prepare for the day with a cute pair of rubber boots and some traditional gardening tools and your children will be more than happy to get involved. By sneaking in a few images while they are busy tending to their plants, you'll create a wonderful, noninvasive way to capture some natural-looking happy memories.

It's a good idea to shoot these sorts of images in the morning, before the sun is too high in the sky and shadows are harsh — and before it gets too hot and young people start to wilt!

(Photos: Allison Cottrill)

ADDING STYLE
Combining a bit of fashion with an activity can produce really great-looking images. Here the ladies' floral themes not only complement one another, they also reflect the garden setting. Try to tie elements of the shoot together for a professional look.

Combining color images with black-and-white in a photo shoot adds variety, and in this particular setting it adds to the historic look of the house and garden.

Technical information

Aperture	f/4
ISO	200
Shutter speed	1/250
Lens	24-70 L

TO RECREATE THIS SHOOT
try the following:

It's all about the props: Tennis racket, umbrella, seed box — a pretty garden provides a natural backdrop, but adding outdoor-related props will give foreground interest to your images and your subjects something to play with.

. .

Transform your own garden: For those of us who don't happen to own or have access to a garden as grand as this one (most of us!), be creative with the outdoor space you do have by adding pot plants in strategic places.

. .

Use the natural light: Most gardens will offer variations of light and shade. Experiment in different spots at different times of the day before your shoot to establish your favorite combinations.

. .

Grease Is the Word

What child doesn't love candy? Add a retro-styled, 1950s-inspired theme and you'll have a surefire success on your hands. Start scouring yard sales and friends' homes for relevant items that will help you build a diner set in your own kitchen. Incorporate old-fashioned candy — if you're feeling adventurous and there's one nearby, see if a local candy store will allow you to shoot inside the store for a short time. Most store owners are more than willing if you purchase your candy on-site.

COLOR ACCENTS
If your theme involves lots of bright colors, make sure you get plenty of them in your images. Maximize opportunities with the props you introduce, such as this jar stuffed with brightly colored candies.

BUDDING ACTORS
With such a strong and popular narrative theme, come up with a few scenarios from the movie *Grease* and ask the children to act them out — this helps them focus on something other than the camera.

ALL-STAR CAST

Bring some spare clothes that fit the theme of the shoot in case any guests need dressing up. You don't want anyone to miss out on the fun, but an off-theme outfit will spoil the pictures.

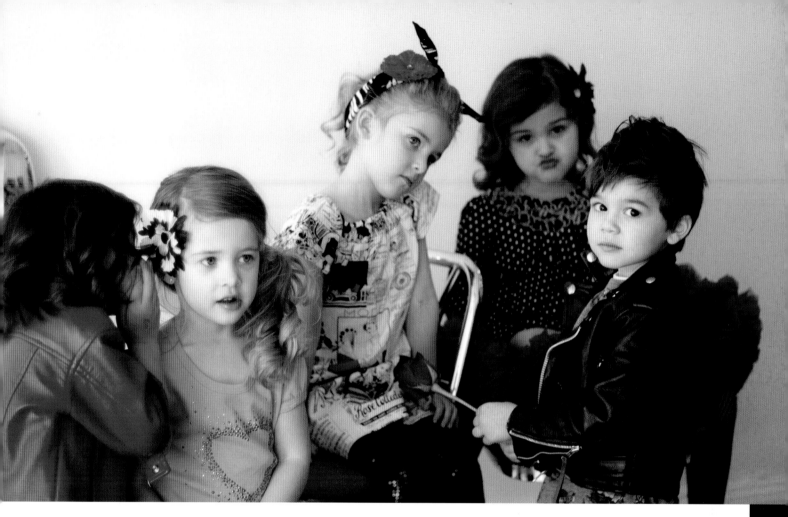

TO RECREATE THIS SHOOT
try the following:

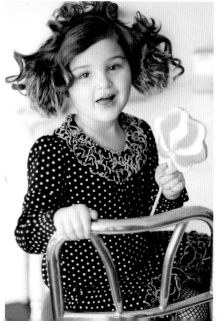

Small or large scale: As in the original musical, a diner setting suits a wide-framed group shot (above) but also a more tightly cropped individual shot (left). Keep your set the size that suits your subjects and props, and bear in mind that it's an ideal theme for portraying young romance (above and far left).

. .

Near a window: Take pictures like these in an indoor kitchen area or local ice-cream or candy parlor; ensure there's enough natural light

so that you can keep fast shutter speeds while using low ISO settings.

. .

Get the look: Leather jackets and 50s' dresses will give your shoot authenticity, but a more cost-effective way of achieving the look is to focus on the hairstyles — greased-back sides for boys and curls and head scarves for girls.

Technical information

Aperture	***f*/1.4**
ISO	**250**
Shutter speed	**1/800**
Lens	**50 mm *f*/1.4**

Squeaky Clean

This is such a fun way to cool off on a hot summer's day. We started with an old metal washtub (or a large rubber horse feeder also works well) and filled it with a small amount of water and baby soap before carefully adding the children. Alternatively, if you'd rather avoid using water, put your children in the bucket and fake the shoot by placing a small pile of soap bubbles on their heads and in their hands to help keep them sitting still just long enough for you to capture the shot. This scene is also great after a cake-smash session (see pages 128–129) to help clean up.

TO RECREATE THIS SHOOT
try the following:

Make it warm: When shooting indoors, make sure the room temperature is cozy and warm.

. .

Keep it natural: The neutral color scheme of the backdrop and towel adds to the purity of the photos.

. .

THE GREAT PRETENDER
If your youngster doesn't look too thrilled at the prospect of bath time, a few well-placed soapsuds and a fluffy white towel can create a realistic illusion.

Technical information

Aperture	*f*/1.4
ISO	250
Shutter speed	1/2000
Lens	85 mm *f*/1.8

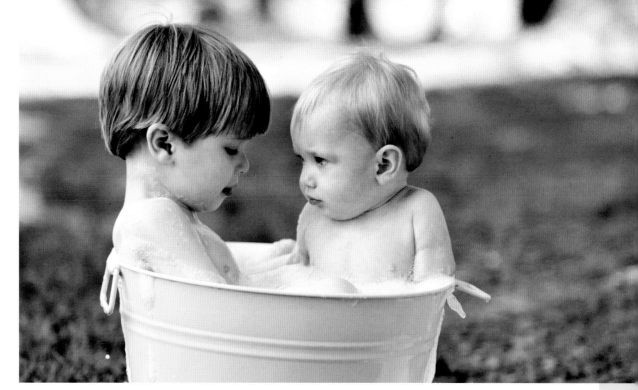

TWO'S A CROWD
As always, look for variety in your cropping, angles and combinations of subject (if shooting siblings). Get close-ups of wet, soapy faces as well as longer shots showing the entire setting; some will be single-subject shots, and others will show the siblings interacting.

TO RECREATE THIS SHOOT
try the following:

Finding a tub: A large washtub or even a clean rubber horse feeder should be big enough for large babies and small toddlers.

Think ahead: To avoid post-shoot meltdown, remember to take towels and dry clothing for afterward.

Where to shoot: Any outdoor field area or even an urban outdoor area that is open (and safe) will do the job. Avoid bright direct sunlight, which will create harsh shadows.

ASSISTANT TO THE RESCUE

With kids in buckets, it pays to have a helper on hand in case they should topple over and find themselves trapped under the bucket with water gushing over their heads.

Technical information	
Aperture	*f*/1.4
ISO	250
Shutter speed	1/2000
Lens	85 mm *f*/1.8

A Toast to Childhood

This shoot would work just as well with a brother and sister as it does as shown here, with two little girls. The aim is to celebrate the innocence of childhood. Start by placing a small old wooden table outside in an idyllic rural location. Use a few small teacups, which you may already have stashed in your cabinets at home, as the "toast" prop and some strawberries to add a pop of color while also reinforcing natural goodness and health. Simple outfits — and a diaper! — that complement the white furniture were chosen here, and together they reinforce the theme of innocence and nature. Of course, don't forget to invite your child's plush friends as well — nothing says childhood more effectively than a large fluffy teddy bear or a well-worn rag doll.

TABLETOP GUESTS
These on-table poses emphasize that this is truly a children's tea party. Especially if attempting this shot with babies or toddlers, have some helping hands just out of shot — or even crouching behind the table — to prevent any tumbles.

MAXIMIZE YOUR EFFORTS
Having done all the hard preparation, try to shoot at a time when you'll get lovely soft, atmospheric light. Here it highlights the girls' flowing long hair.

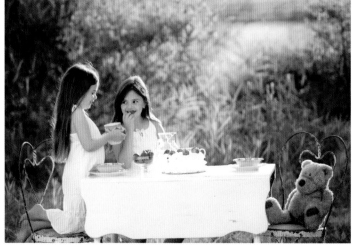

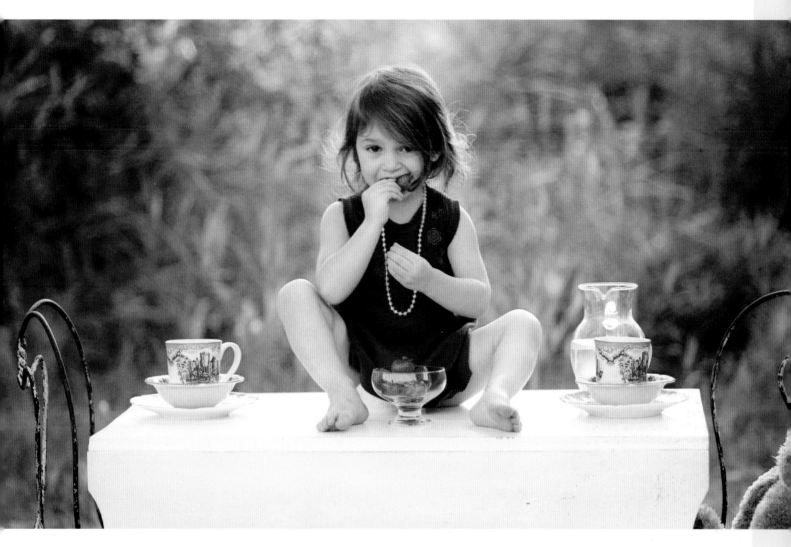

TO RECREATE THIS SHOOT
try the following:

Golden glow: Try to take your pictures in the golden hour, when the sun is low in the sky and slightly behind the subjects, to achieve the warm, glowing effect seen here.

A spot in the country: A simple rural backdrop with no artificial elements is ideal. There's lots of foliage in the background here, but an open field would work just as well, especially if there is a large tree in the middle to anchor the shot and add to the composition.

Faking it: For an easier shoot that's closer to home, find a natural backdrop, such as a bush or a tree, shoot in the golden hour and crop in to your subjects, who should be wearing white and maybe carrying their favorite toy. The natural, glowing look of the scene will be the same, minus the tea-party accessories.

Technical information

Aperture	**f/1.8**
ISO	**250**
Shutter speed	**1/2000**
Lens	**85 mm f/1.8**

Fast Asleep

Nothing says innocence quite as much as a newborn baby who's sound asleep. Photographing babies, or even older toddlers, when they're napping gives you the ideal opportunity to capture them looking totally relaxed and at peace — and their vulnerability makes for some really heartwarming images. The best part is that you don't need many props or much styling, except for perhaps a woolly bonnet and a cuddly toy. Just place your snoozing subject on a soft blanket, gently mold the shape, if required (see Newborns, pages 78–79), and let the expression speak for itself. (Photos on this page: Carrie Sandoval)

HEAD GEAR
Apart from looking irresistibly cute, a bonnet (below) or natural-fiber "hood" (above) will keep the head warm, which is important in the absence of clothing.

TO RECREATE THIS SHOOT
try the following:

Earth tones: The natural look of these photos is enhanced by the natural fibers and neutral colors that surround the baby's skin. Use frayed burlap and unraveled wools, but make sure they are soft enough to make a comfy bed.

On a level: Try to avoid pointing the camera directly down when photographing. Rather, stoop or crouch to more or less the same level and shoot from there — viewers will respond better to this angle of view because it's more intimate.

Technical information

Aperture	f/1.6
ISO	400
Shutter speed	1/800
Lens	50 mm f/1.4

TO RECREATE THIS SHOOT
try the following:

Avoid flash: Before you settle your baby, remember you're going to need quite a lot of light in order to photograph. Avoid using a flash, which can create unnatural-looking light — and could wake your baby. Instead, place your baby on a daybed or crib that's near a window or in open shade outside if it's warm enough.

......................................

Vary your angle: Angle your camera to give you lots of different viewpoints, and remember to fill the frame so that you're not left with expanses of empty blanket in the shot.

......................................

Shallow focus: Use the widest aperture (smallest number) and make sure you accurately focus on your baby's eyes; these will remain in focus, but the rest of the image will be progressively blurred for a professional look.

Technical information

Aperture	*f*/1.4
ISO	400
Shutter speed	1/250
Lens	85 mm *f*/1.4

COVERING UP
Although your baby may show no signs of stirring, as with these babies, remember that babies get cold quickly, so keep them covered up if taking any sort of break between shots, to adjust settings or change memory cards, for example.

Country Bumpkins

For those of you who live in areas with lots of farmland, you have ready-made backdrops for your images. Using such scenery as the location for a shoot (see also Down on the Ranch, pages 104–105) provides the perfect opportunity for dressing up girls in folksy frocks and boys in natural knits, and letting them explore nearby outbuildings (if it's not your land, remember to ask permission). Walking through fields and taking in the sights, sounds and smells can do wonders for your creative — and playful — side.

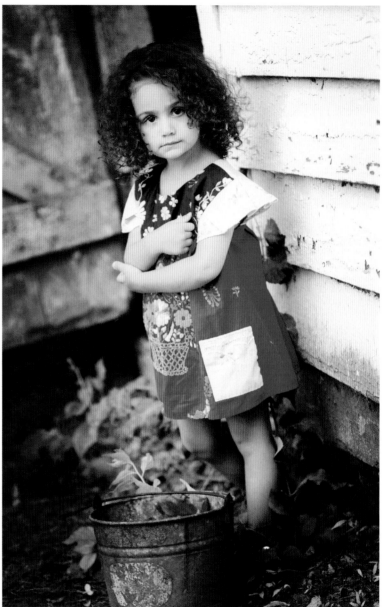

TAKE YOUR PARTNER BY THE HAND!
If you take a portable music player with you to the location, you can play good ol' fashion country music and get your guys and gals to dance around. They'll grab the opportunity to have fun while you grab some priceless images.

DO YOUR HOMEWORK
Scout around the location to see if there are other props you can move around to make miniature sets. There are bound to be things at home that you can bring along to embellish what's already there.

TO RECREATE THIS SHOOT
try the following:

Mucking in: Don't be afraid of dirt — use it to your advantage in this type of shoot to emphasize the country location and the shabbiness of the outbuildings or the earthiness of plowed fields.

Folk appeal: Incorporating hand-crafted fabrics adds color and is in keeping with the country theme. Look for patchwork, embroidery, knits and crochets. Even just as a feature shawl or blanket, they will make all the difference.

Technical information

Aperture	*f*/1.4
ISO	250
Shutter speed	1/800
Lens	50 mm *f*/1.4

LITTLE MISS SUNSHINE
To achieve the glowing halo of hair and bright background, shoot with the sun low in the sky and slightly behind your subject.

The Diva

The secret to keeping even the most overly rambunctious little girls seated for more than a minute? Makeup. No little girl can resist a shiny, forbidden tube of bright red lipstick. Pair it with a sweet tutu and bare belly; you can add some inexpensive costume jewelry for extra sparkle. While you should allow your child to play relatively freely with the makeup, don't allow her to cover herself — it won't make for attractive photos, and it's hard to remove. In our shoot, the balance was just right, and the shoot was a favorite for both mom and daughter.

LIP SERVICE
This little one just about eats her lipstick, and you might want to copy drawing a heart motif on your diva's belly. Before you do, check to make sure you use makeup that's been properly tested so it's safe to use in this way. Young skin is very sensitive, and the shoot won't work if you're trying to stop the lipstick from going in the mouth!

TO RECREATE THIS SHOOT
try the following:

Harnessing natural light: This is an indoor shoot and should be done near a window or at mom's vanity. Make sure you have enough natural light to work with and that the light creates the all-important catch lights in the eyes (see Look into the Eyes, pages 34–35).

Organizing the confines: A nice, comfy stool or chair for your child to sit on will help to keep her contained to one area.

Mix and match: A strong color of lipstick with matching tutu works well here, but for an even more vibrant shot try contrasting colors of makeup and clothing.

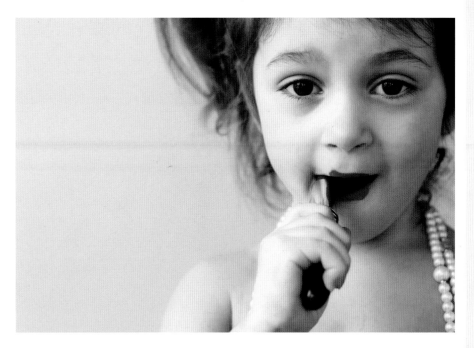

FOREWARNED IS FOREARMED

When the lipstick's out it's more than likely going to end up on furniture, cushions, clothes and the like. Don't use anything valuable on set. Similarly, if your little diva has long hair, it's best to keep it tied up and out of the way; that also makes it easier to do close-ups of faces.

Technical information

Aperture	f/3.2
ISO	200
Shutter speed	1/800
Lens	85 mm f/1.8

EYE CONTACT

The variations of the diva's gaze — to the side (opposite), to camera (above) and down to the lipstick (below) — make for a dynamic series of photos. Dare to venture beyond the traditional straight-to-camera portrait.

Cake Smash!

For a first birthday there is no shoot more exciting for a child than a cake smash. Letting your baby try cake for the first time in front of your camera can produce some truly spectacular results. For most sessions you will need an extra adult on hand to help with your squirmy and frosting-covered tot. You might also need to initialize the crumbling of the cake, since many babies are hesitant to dig in first. Make sure to focus on the details in this session as well. Shooting close-up before and after images of the cake can make for a delightful storyboard to document your fun adventure together.

CHOOSE YOUR CAKE WISELY
The color of this icing works well with the wooden floor, and the monkey figurine is fitting! If you want to go for an all-out mess, get a cake with lots of cream and soft chocolate fondant (and stand well back). A drier, plainer sponge cake with colorful icing is a cleaner alternative.

TO RECREATE THIS SHOOT
try the following:

Reflective flooring: Aside from the practical aspect of an easier cleanup, a shiny hardwood floor is an ideal surface because it contrasts nicely with the bright cake and reflects light and whatever is placed on top of it.

Tasty alternative: For a different take on this shoot, try using cupcakes scattered around the floor and on your child's lap. If it's his or her first cake experience, your child might feel less intimidated by these smaller options.

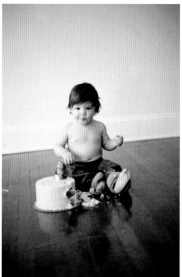

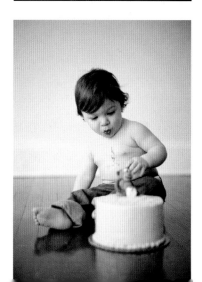

SCALE OF REFERENCE
This creative close-up not only shows the cake in all its glory and the perfectly shaped foot, but it also provides an idea of size, emphasizing the cutely miniature dimensions of the cake smasher.

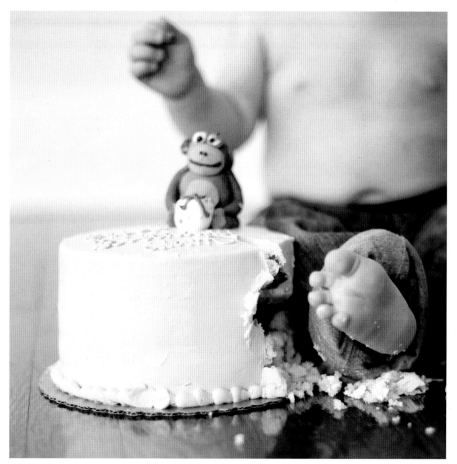

MINIMIZING MESS

If you don't have a nice shiny wooden floor that's easy to clean, you may want to use a blanket that can be brushed down and washed and shoot outside, in the yard.

Technical information

Aperture	*f*/1.4
ISO	250
Shutter speed	1/6400
Lens	50 mm *f*/1.4

Brave Knight

What red-blooded young man hasn't wanted to wield a flashing sword against the ferocious dragon that's terrifying the nearby village in order to capture the heart of the fair princess? Boys have played at being brave knights, since, well, the time of brave knights! But you don't need a snorting steed, a suit of armor or a 13th-century castle to quickly slip into this land of make-believe; some of the bravest knights go into battle with a paper hat, a drape cape and a plastic sword — and they always vanquish their foe.

TO RECREATE THIS SHOT
try the following:

Enter into the spirit: For shots like this to work you have to keep feeding the narrative. Tell your son you're the dragon and that he has to slay you to proceed to the next challenge, then shoot away as he comes at you with his sword.

.......................................

Days of yore: Old-style props, such as this boat, and using black-and-white will transport your hero back in time and enhance the overall fairy-tale look.

.......................................

Technical information

Aperture	f/2.8
ISO	200
Shutter speed	1/500
Lens	85 mm f/1.4

EXPRESS HIMSELF
This ferocious snarl adds to the theme. Get your knight to howl and grimace as he wields his sword.

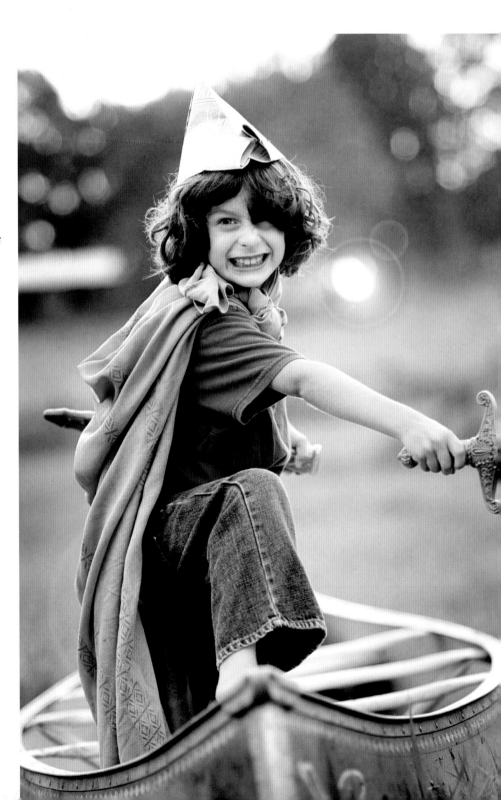

TO RECREATE THIS SHOOT
try the following:

No castle required: You don't need a vast area for a brave knight's arena; some open parkland or fields will be fine, and if there are some old-looking wooden structures, even better.

. .

Shutter speed: Use a shutter speed of around 1/250 second or more to freeze some of the action. If you can, set your camera to shutter priority, set a shutter speed of 1/250 second, and let the camera worry about the aperture.

. .

Technical information

Aperture	*f*/5.6
ISO	200
Shutter speed	1/250
Lens	85 mm *f*/1.4

ANGLES OF ATTACK
Vary the angle of your shots. Lie on the ground and have your knight stand over you as if vanquished, then stand tall as if your knight is looking up to fight the fearsome dragon.

Post-Production Tips and Tricks

There's an old beauty tip that says the key to getting your makeup to look perfect is to keep your skin in great condition. Starting with a great canvas will help your makeup enhance your face. People should notice you, not your makeup. If you think about it, the same principle applies to editing your photographs. To yield positive results, you must begin with a well-exposed, clear image. With such an image as your starting point, there is an abundance of editing tools at your disposal that will help you tweak your photo to perfection. Then all that's left is to decide how you want to show it off, whether it's sharing online, displaying in your home or preserving for future generations.

Easy Editing

If you're new to photo editing, don't dive in with expensive and complex software such as Photoshop — start with something less expensive and easier to master.

Even if you don't have a computer, you may be surprised to discover that you can still improve the look of your images after you've taken them. Most point-and-shoot compact cameras, micro four-thirds cameras and many entry-level digital SLRs feature in-camera editing. Typical editing functions include cropping, straightening, red-eye removal and exposure and color adjustment. A quick look in your camera's manual will show you how to perform such editing tasks.

Image Styles

As well as allowing you to make some basic editing choices, such cameras also usually feature a variety of shooting styles or filters. Among the more common ones are black-and-white and sepia effects, but many cameras are more sophisticated, offering selective coloring, grainy black-and-white, high-key and low-key styles and high-contrast color options, to name just a few. Again, check in the manual to see what options your camera has.

The ability to edit your images in-camera and apply various styles means that you can print or upload your images to the web directly from the camera. For those of you who aren't interested in image editing, such options will be sufficient and provide you with all the control you want or need. However, I know that many photographers are also keen to learn a little about image editing using a computer and editing software.

Where to Start?

The best place to start with photo editing is the free software that came with your camera. This is usually simple to understand and can fix most of the small details, such as straightening, cropping and red-eye removal. Created specifically to suit the nonprofessional, this avenue is highly recommend as a stepping-stone to editing before you go out and purchase more expensive and complicated software.

Free Software

If your current camera did not come with any additional software, try a quick search on the web, and you'll soon find a few free photo-editing options. Picasa 3 and iPhoto are two popular examples, although iPhoto will only work on Mac computers.

Both of these programs can perform all of the basic editing tasks you'll need, and they're simple and fun to use. As a general rule of thumb, work through each of the photos you want to edit using the following steps:

SAVE YOUR DOLLARS
Before spending money on editing software, try out some of the free programs, such as Picasa, that you can download from the Internet. These may well have all the functions and features you need.

1) Using the crop tool is the best way to cut out distracting backgrounds and zoom into your subjects.

Drag the crop tool over the area you want to keep.

2) Once you've cropped into the shot, you may need to use the rotate tool to straighten the image.

1) Crop Most images benefit from being cropped. Cropping an image allows you to cut away unwanted elements of a photo. You may, for example, want to cut away some distracting background and close in on your subjects' faces. Simply drag with the crop tool over the area you want to keep.

2) Straighten No matter how careful you are at the time of shooting, there'll be occasions when you realize later that the image isn't straight. Again, even the most basic editing software will allow you to straighten an image. You can usually straighten an image by dragging a slider or rotating a corner of the image.

The histogram details all of the tones in the image.

The cropped and straightened image has much more impact.

3) Red-eye When the bright light from the camera's flash passes through the subject's pupil and reflects off the back of the eye, it causes red-eye. Many cameras today will fire a preflash, or red-eye reduction flash, which forces the pupil to close slightly so that the light cannot pass when the real flash fires. In most cases fixing red-eye with editing software simply involves highlighting the affected part of the image, and the software then automatically removes the red color.

4) Lighten and darken Although it's important to aim for accurate exposure at the time of shooting, you'll often find you want to lighten or darken an image when you come to reviewing it on-screen. Use the relevant sliders judiciously, and make sure the image still looks realistic.

5) Contrast and color One of the final aspects to check is the contrast and color of the image. Many photos will benefit from a slight boost in both contrast and color to give them more impact. But don't go overboard, otherwise the image will start to look fake. Use the sliders to increase the contrast and color a little at a time.

6) Blemishes Check carefully for any skin blemishes or marks. We all get the odd pimple or mark from time to time, and it only takes a matter of seconds to brush these away using editing software.

7) Special effects Finally, many basic programs offer various special effects, such as converting the image to black-and-white, adding a soft focus or glow effect or something similar. By all means experiment with these effects and use them occasionally, but avoid overusing them.

The special effects and filters options.

Add effects for greater creativity.

7) Applying Picasa's soft focus filter blurs the edges of the frame and emphasizes the faces.

Following these basic steps will, in most cases, provide you with finished images that you can then print out for your admiring viewers or upload to a social networking site.

ADDED EXTRAS
Check to see if there's any editing software provided with your camera. So-called bundled software can be surprisingly comprehensive, and the best bit is that it's free.

The Next Step

If you get bitten by the editing bug, there are a host of image-editing programs that will help you achieve truly breathtaking results.

The most talked about editing software on the market is Photoshop. However, this program requires a lot of time and skill to fully master. It is powerful and expensive software that may be unnecessary for the at-home user. For those of you who may have jumped the gun and obtained the software already, I would encourage you to do some extensive home study; there are hundreds of books available to consumers addressing Photoshop and its editing processes. The Internet is also a useful source of information. I often use the web as a go-to for those quick-fix questions about my Photoshop software. Online video tutorials are abundant and can help you practice and perfect your editing skills.

Photoshop Alternatives

If you are considering buying Photoshop as the ultimate image editor, you may want to have a look at some much cheaper alternatives before spending your money. Photoshop Elements and Corel's PaintShop Pro are both significantly less expensive than Photoshop, but both feature almost everything that Photoshop has to offer in terms of photo-editing capabilities, and you can download them for a free 30-day trial period.

Other software programs to consider include Lightroom and Apple's Aperture. Again, both are considerably cheaper than Photoshop, and although they don't offer the same level of editing capability, many people find them more intuitive.

Software Application Tools

Personally, I use Photoshop for the little details that might have been missed while shooting. It is often the case that I pull up an image in Photoshop and notice small marks on a child's face or arm, for example. A quick application with either the spot healing or clone stamp tool quickly fixes these. There is also the familiar situation of a mom coming in for a maternity session and having some concerns about

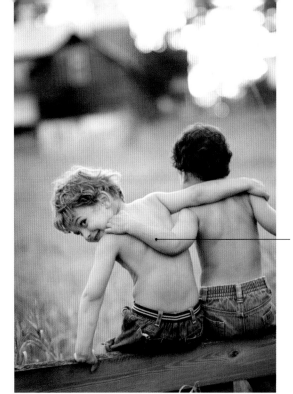

REMOVING BLEMISHES
While cuts, grazes and bruises are all part of growing up, there may be times when you find they are distracting attention away from the main focus of the image. Software can be used to clone away such blemishes.

This scratch is in a prominent place.

1 Zoom into the area you want to work on.

2 Use the clone tool or the tools under the healing brush to paint over the blemish.

3 Check for other smaller blemishes and, if they bother you, fix them in the same way.

4 The end result is a more visually pleasing area of skin, which is less distracting yet still looks natural.

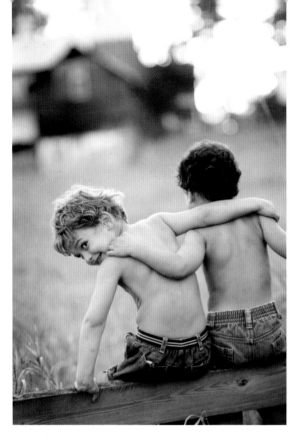

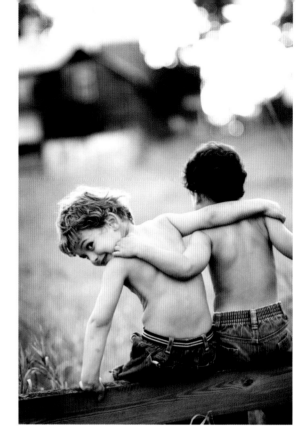

PRE-CURVE PHOTO
This image has masses of charm and character, but it looks a little flat and lacking in contrast.

POST-CURVE PHOTO
An S-shape curve adjustment adds contrast by brightening the highlights and darkening the shadows.

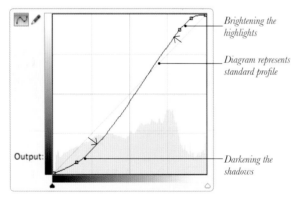

Brightening the highlights

Diagram represents standard profile

Output:

Darkening the shadows

Curves palette

stretch marks accrued during the pregnancy. In this situation I will gladly whisk them away to ease the client's angst.

Two other tools I turn to when preparing images for a client are the curves and unsharp mask tools. These essentials can be found in most software programs. My personal style is to leave my images with the color a little punched up, but not so much that people start to look unnatural.

Using the curves tool I like to brighten the highlights while at the same time darken the shadows. This creates the characteristic S-shape curve and results in an image with a bit more punch. I shy away from doing this on every image, but it's definitely one of my favorite post-production tricks.

Another technique that I highly recommend is using a sharpening tool before you print your images. Again, this can be overdone and can make your images appear too noisy, but when used correctly it can make all the difference

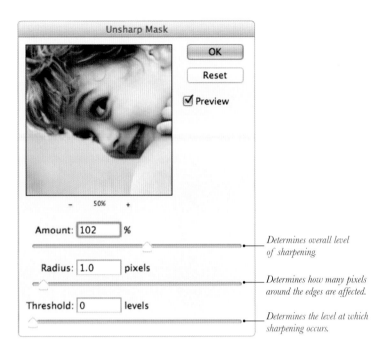

Determines overall level
of sharpening.

Determines how many pixels
around the edges are affected.

Determines the level at which
sharpening occurs.

EYE-POPPING IMPACT
Often an image can be made to "pop out" with a careful application of the unsharp mask sharpening command. This increases contrast around edges, making the image crisper and sharper. Too much sharpening can result in ugly haloes.

in your final prints. Always review your images at 100 percent or "actual pixel" size before printing them. At this scale any overused technique is soon made apparent. While it's fun to play around with all the options available to you, the overuse of editing tools will show through. Always be mindful of how much editing is necessary and how much is just for creativity's sake, and you will be able to gauge what looks best for your work.

Actions

Also available for most editing software are "actions." These are like mini programs that you use with your main editing software to automatically produce interesting effects. There are actions for vintage effects or to add bursts of color to your images, and many are freely available online. Be careful not to use the same action too often though, since you may end up with images that appear predictable.

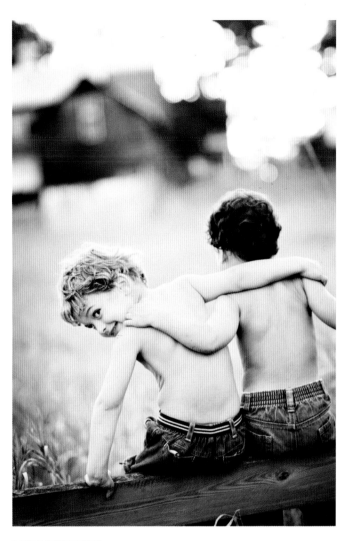

POST-ACTION PHOTO
Actions are mini programs that run a prerecorded set of adjustments and amendments to an image to create a specific affect, such as this vintage-retro wash.

Displaying Your Photos

Working with your photos — sharing, scrapbooking and hanging — has never been so full of creative opportunities.

Recent advancements in technology have created a world in which sharing images and videos of our children with friends and relatives across the world can be as simple as clicking a computer mouse. There are so many different options when it comes to sharing and displaying our favorite photos that an entire book could be devoted to just that. So let's stir up some creative juices with a few ideas.

Social Media

Sharing your images on social networking sites, such as Facebook and Twitter, is a great way to keep loved ones up to date on key moments and milestones in your child's life. With the availability of instant sharing via mobile devices, the digital age has taken the phenomenon of virtual sharing to the next level — and it's all so easy! A baby's first steps, the first unaided bike ride and countless other monumental moments can be captured and shared both instantly and wirelessly like never before.

Canvas Prints

Canvas prints have really taken off in recent years, and they are now one of the most popular ways to display images. So what exactly is a canvas display? Images are first printed on a large piece of canvas and then stretched and wrapped over a large wooden frame. Depending on the company you use, the backs are also covered. Usually the frames are fitted or supplied with screws and hooks, making the piece ready to hang on the wall.

I adore the impact of a large canvas hung alone on a wall. The best part about canvas prints is that they exude the look and feel of a professional artwork, creating an impactful, beautiful image. As you become more adept with your image-editing software, try creating a bright and colorful canvas collage of your favorite images.

CREATIVE CANVASES
Whether it's a dominating panoramic canvas or a cute square block, the option of printing onto canvas gives a professional look to your photos.

Slideshows

Slideshows are a fun way to electronically share your images, whether you use an elaborate, dedicated slideshow program or a free one you've downloaded from the Internet. Most slideshow software will allow you to add a musical soundtrack that will play during the presentation, and there are some great online sources for music to pair with your images. With caption and border options, photos take on a whole new life. And remember, slideshows can be burned to a DVD. Add some pretty wrapping paper and some ribbon and you have homemade gifts to pass out on special occasions. Do you publish your own blog? Add your family slideshow to it, and see how this personal touch can transform your site.

Photo Books

Photo books are similar to traditional albums, but so much more professional looking. If you find the right supplier, photo books will be beautifully bound with images printed on thick glossy or matte paper. Most companies will provide the consumer with templates for customizing the covers, and some will even provide an option for engraving the cover with an elegant font. We have a version of such a photo book in our studio, and it is our most sought-after product. Photo books make wonderful keepsakes and a heartfelt gift for the entire family for years to come.

Calendars, Coffee Mugs and Key Chains

Most photo labs offer these fun and quirky products; they're a great way to show off prized images and make neat little gifts for friends and family. Just think how happy Grandma will be when looking at a new and wonderful image of her granddaughter at the start of each month. The best approach is to create a new image of your child each month and design a calendar to coincide with those images. What a fun way to look back on how much your child has grown over the year.

Scrapbooking

With an ever-growing group of followers, scrapbooking has become quite the phenomenon over the last decade. Any craft store will have hundreds of paper choices and embellishment options, including stickers, hobbyist icons and more. In our booming technological era, digital

scrapbooking has also taken off with just as much passion from its followers, allowing users free resources and free reign in popular websites. Any simple search for templates will bring you a world of possibilities with this creative and personal way of sharing and saving your memories.

GET CRAFTY
Creating scrapbook layouts allows you to add extra elements that can help tell the story behind the picture.

Hanging Your Images

With so many framing options available today, how you frame your images can become an extension of your design taste. Whether done in-home or sent out for the professional touch, a frame can make a world of difference for your prints. Frames should match the decor of your home and accentuate your images perfectly. Choose matting that complements the colors in the background of your images or the paint on your wall. This will help pull the entire look together. New trends in framing are always popping up, from the nonexistent mat to glassless frames. Some have colorful, whimsical borders, while others have a classical, timeless feel and use traditional wood. Whatever style you choose, remember to take precautions to protect your images. Avoid hanging your prints in direct sunlight, and keeping them away from humid areas will boost their longevity.

MAT EXPERIMENTATION
The color of mat you choose to go in your frame can make a big difference to the overall look of your image on the wall. The perfect mat should complement the photo rather than distract from it, so try a few against your image before you buy.

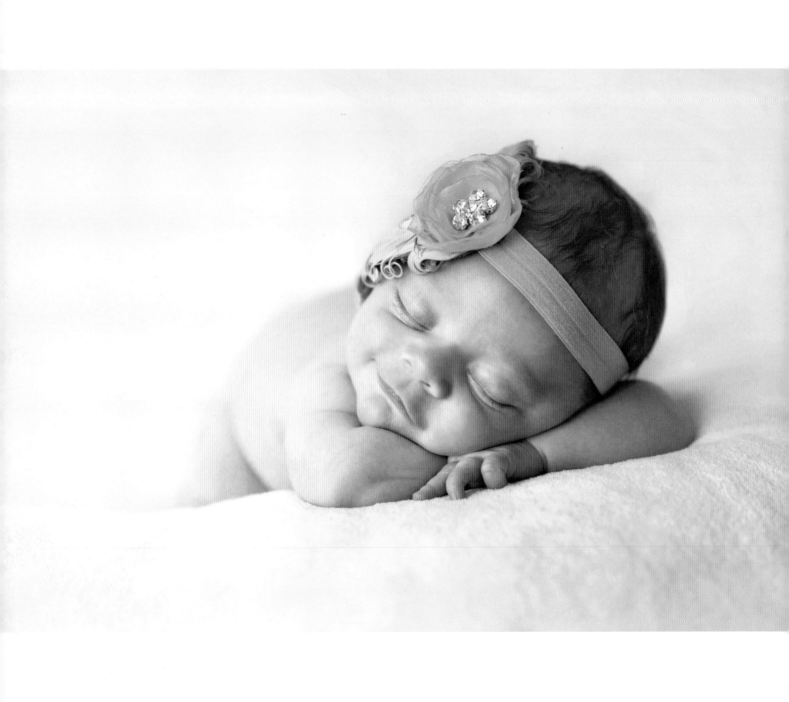

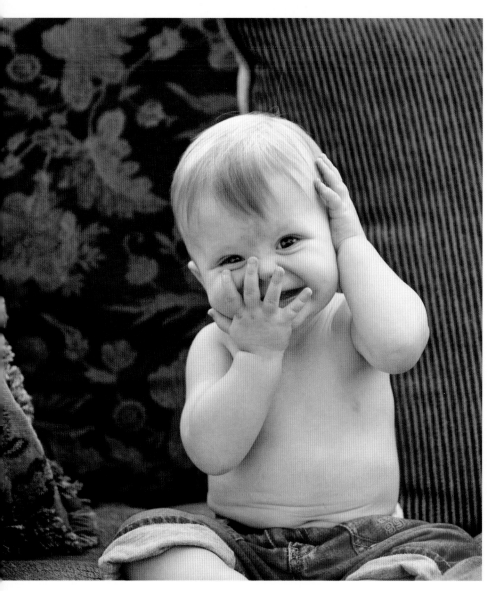

Gallery

Taking a look at how other photographers snap such irresistible images of children of all ages is sure to fuel your imagination and motivate you to put into practice all you've learnt about photography, your camera and using your children as subjects. Here is an adorable selection of varied professional images to coo over. Be inspired!

SWEET DREAMS
Opposite: Aneta and Tom Gancarz captured this 5-week old in deep and happy sleep by using the light from a window to the left and a reflector as fill on the right.

A LAUGH A MINUTE
Heather Mosher illustrates the perfect use of background textures here, having simply puffed up some pillows and placed a little giggler in front.

Newborns

DYNAMIC CROP
Top: Having part or parts of your subject touch the frame draws attention and gives an intimate viewing experience, as photographer Helen Rae proves here.

RICH REDS
With ISO 800 and an 85 mm lens at *f*/4, Aneta and Tom Gancarz featured red woolen textures to offset this sleeping star.

LEAN ON DAD
Rachel Hein captures a newborn's attachment to Daddy, producing an eye-catching composition and a classic portrait.

PRETTY IN PINK
A nicely angled full-length body shot by Aneta and Tom Gancarz portrays this newborn in her perfect entirety. She is lit by natural light and a reflector, which is used as fill on camera-left.

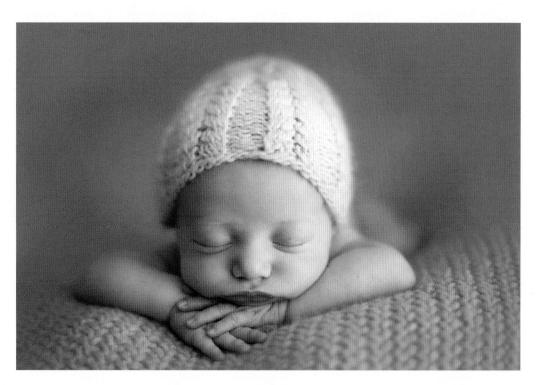

BEAUTIFULLY BLURRED
By using creative blur around her 7-day-old subject, Carrie Sandoval produces an appropriately soft image, which is further enhanced by the neutrally toned woolly hat and blanket.

Babies

PEEKABOO
One soft box, two backlights and a Nikon
D700 and Sandi Ford was able to snap
this 4-month-old peeping out from his
blanket. Note how the blanket frames
the baby's face.

LITTLE SOFTIE
Sandi Ford puts a soft box to perfect use
here, diffusing the light and keeping it
soft and shadow-free to emphasize the
purity of the subject.

MAKE YOUR OWN STUDIO
Photographers will often travel to a client's home, which means it is possible to set up a mini studio in your home. A black sheet or large piece of card stock will replicate the dark background that provides the contrast in Sandi Ford's image shown here.

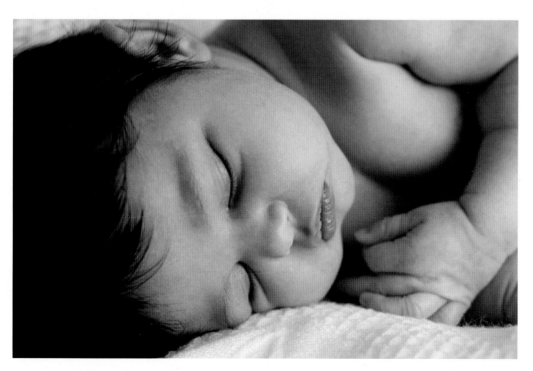

GETTING IN CLOSE
Often it's as much a case of choosing what not to show as it is deciding on the main focus of the image. It takes an expert eye, such as that of Siobhan Murphy, to find such interesting and unconventional angles and crops — and to make them work so effectively.

Toddlers

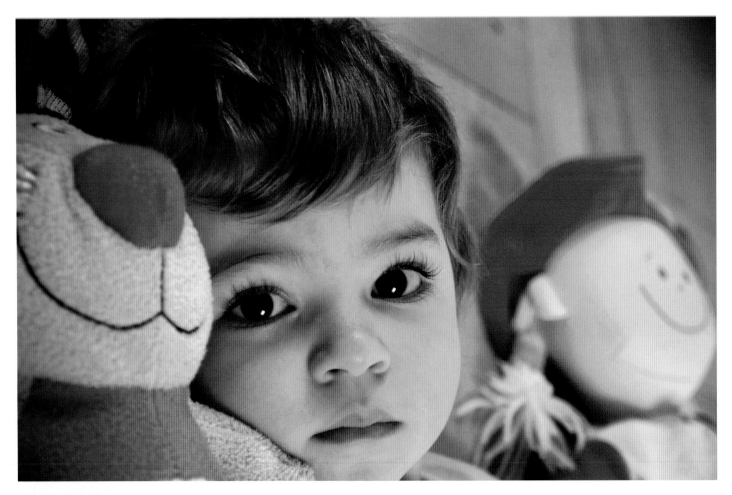

ME AND MY DOLLS
The dolls are used by Tomi Deák to
frame the main subject — who was
caught just before dropping off to sleep
— and to enhance the childhood context.

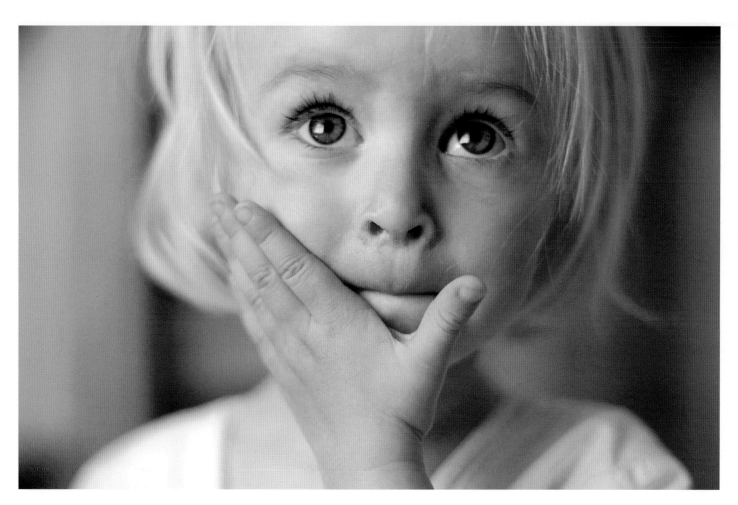

WHOOPS!
Who would question such an innocent-looking face? Malin Lewrén uses a Nikon D80 and ISO 100 to portray the essence of this little character.

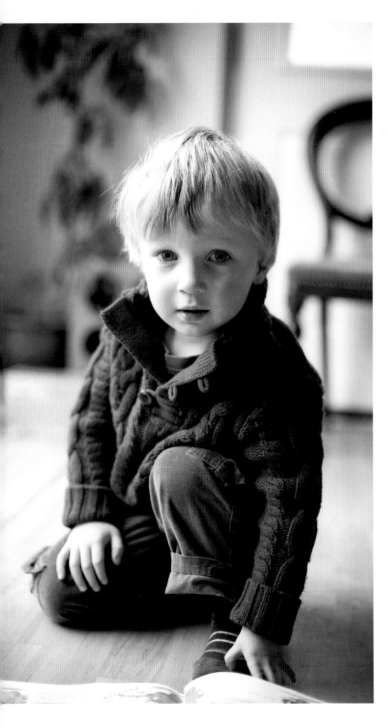
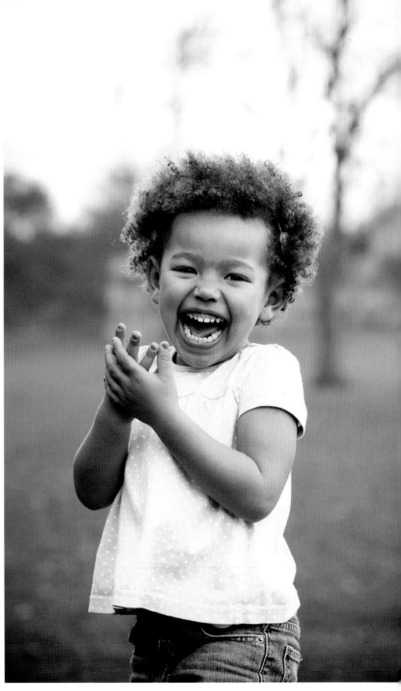

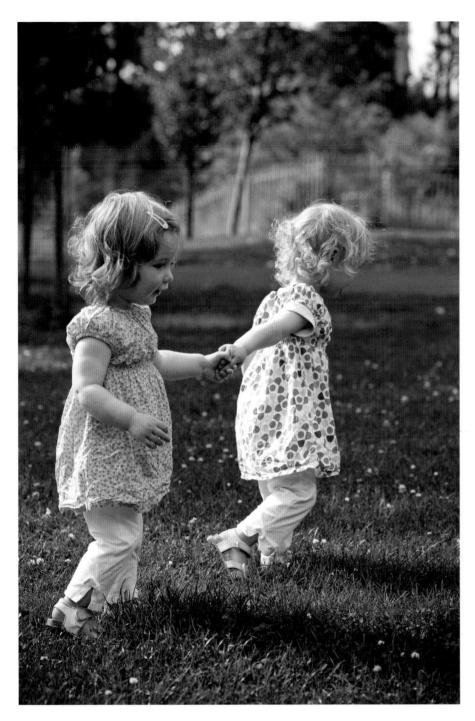

BLACK-AND-WHITE STUDIES
These pictures by Rachel Hein reflect the photographer's interest in taking natural portraits during informal and fun sessions. Shot on location using natural light, the images capture spontaneous moments. Black-and-white adds a timeless quality, ensuring that the images will be treasured family mementos for generations to come.

Children

PLAYING WITH CONTRASTS
Photographer Helen Rae uses contrasting colors, textures and patterns to make her small subject pop out from the background, which also serves as a frame within a frame.

SIMPLE DISTRACTION
Even a prop as simple as a feather can lure attention away from the lens, making for a more editorial, storytelling shot by Rachel Hein.

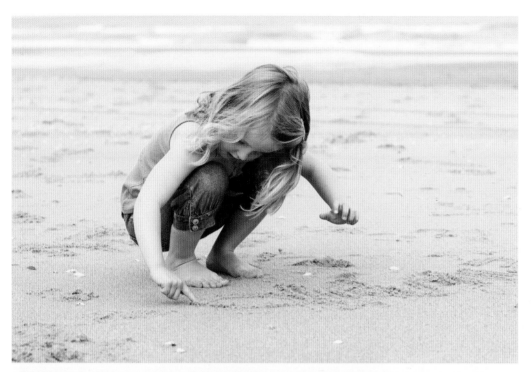

SAND SCRIBBLING
Originally taking studio-only pictures, Helen Rae quickly discovered that her miniature clients responded much more to being out on location. Now she uses natural light and the outdoors to produce lifestyle portraits such as this one.

PLAY AWAY
Encouraging children to be themselves and play together is at the core of Siobhan Murphy's photography. It is this philosophy that drives a shoot that produces natural-looking images.

BUSY BEES

Despite both the background and foreground of this shot being busy visually, Nina W. Melton's shot of these three girls works well, mainly because of the perfect positioning of the props and subjects, and also because of the use of pink and white to tie the scene together.

INNER SPIRIT

Bathed in light, the essence of this little girl beams out of Liz Brown's portrait. Note the interesting angle of the body, which encourages the girl to tilt her head adoringly toward the lens.

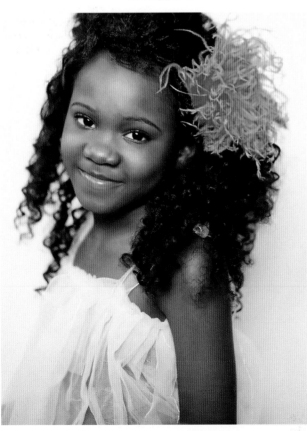

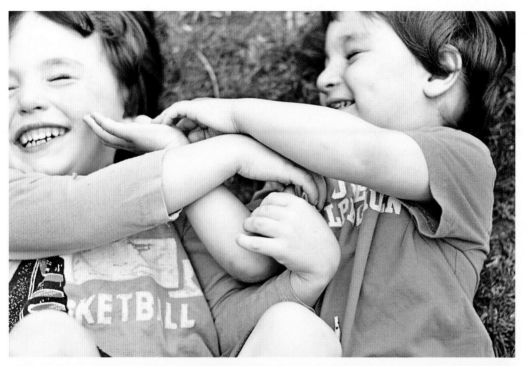

BOYS WILL BE BOYS
Even on one of the hottest days in the summer, these two cousins had plenty of energy and spent most of the day running around. Jess Morgan asked them to lie down and snuggle up, but, boys being boys, they decided to tickle each other instead. The tangle of arms and joy on their faces makes a unique and pleasing image.

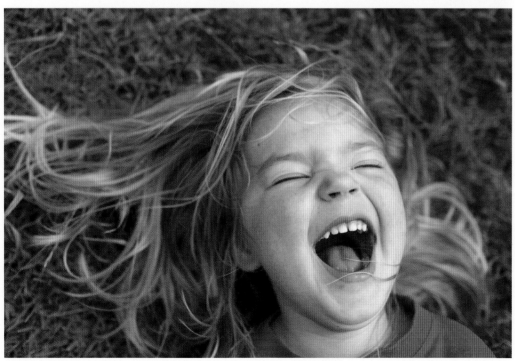

CATCH ME IF YOU CAN
Robert Lang's game of chase with his daughter ended in a tackle to the ground and a fit of laughter. Continuous shooting mode enabled Robert to catch the moment on camera.

Preteens and Teens

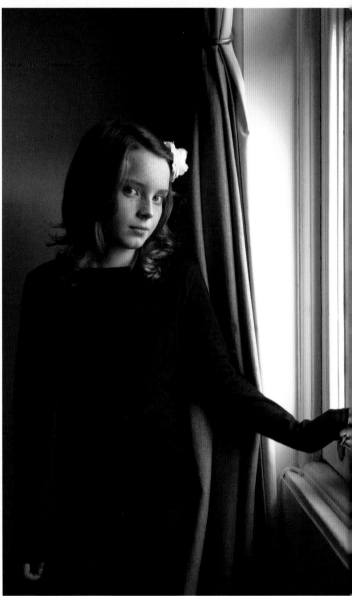

PLAYFUL FRAMING
Allison Cottrill makes clever use of a life preserver to place the giggling girls in a round frame within a traditional rectangular frame.

HOME COMFORTS
By shooting in clients' homes, Ken Sharp captures the essence of a character because his subjects are relaxed and at ease.

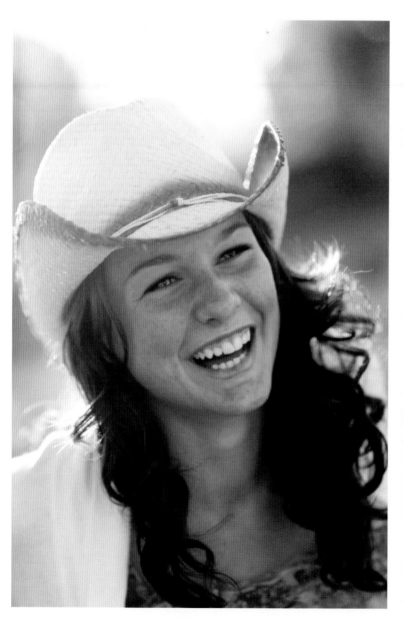

RAY OF LIGHT
Heather Mosher uses the sun to bathe the top of the image in light; the inclusion of the cowboy hat prevents the light from obscuring the subject's sparkling features.

MODEL SON
Even for a pro, photographing your own children can present a challenge, which Heather Mosher overcame by allowing her son to pout and pose his way for this portrait.

Index

Credits

I would like to thank my husband for being a constant source of strength during this journey and my children for your unconditional love. To my clients, for reminding me every day how special and wonderful childhood is, it has been an honor every time you have chosen me to capture these times for you.

. .

PHOTOGRAPHER CREDITS

Quarto and the author would like to thank the following photographers who kindly supplied images for the book. All photos without a photographer's name in the accompanying caption or text are by the author, Heather Mosher.

r = right, l = left, t = top, c = center, b = bottom

Brown, Liz, www.lizbrownphotographyspot.com, p.55, 65, 154r
Cottrill, Allison, www.allisoncottrillphotography.com, p.12, 15, 17, 18, 32, 83t, 114, 115, 156l
Deák, Tomi, www.tomeo.hu, p.148
Ford, Sandi, www.sandifordphotography.com, p.34, 146l/r, 147t
Gancarz, Aneta & Tom, www.atgancarzphotography.co.uk, www.cutebabyphotography.co.uk, p.11, 14, 16, 27t, 30, 57b, 101, 102, 141tr, 142, 144bl, 145t
Hein, Rachel, www.rachelhein.com, p.68t, 144r, 152r
Hyde, Tamra, www.modernexpressionsphoto.com, p.112, 113
Kirichenko, Natalia, Shutterstock, p.53
Lang, Robert, p.155b
Lewrén, Malin, www.familjefotograf.se, p.84br, 149, 150, 151
Luck, Steve, www.steveluckphotography.co.uk, p.29, 92, 95t/b
Melton, Nina W., www.ninawmelton.com, p.94t/b, 154r
Morgan, Jess, jessmorganphotography.co.uk, p.31, 96r, 98, 99, 155t

Murphy, Siobhan, www.siobhanmurphyphotography.co.uk, p.67r, 77l, 78l, 93, 147b, 153b
Pear Photography, www.pear-photography.co.uk, p.78r
Rae, Helen, www.helenraephotography.co.uk, p.22, 90, 96l, 97, 141t, 152l, 153t
Roper, Kelly, www.kellyroperphotography.com, p.50, 52, 67l, 74
Rupprecht, Alicia, www.aliciarupprecht.com, p.33
Sandoval, Carrie, www.capturedbycarrie.com, p.122, 145b
Sharp, Ken, www.kensharp.com, p.68b, 156r
Vimercati, Mariacristina, www.mcristina.com, p.26
Wenzel, Amy, www.amywenzel.com, p.38, 84c

p.58 With special thanks to Geddy Spencer.

Quarto would also like to thank the following companies for providing product shots:
www.nikon.com
www.canon.com
www.crumpler.co.uk

All other images are the copyright of Heather Mosher or Quarto Publishing plc. While every effort has been made to credit contributors, Quarto would like to apologize should there have been any omissions or errors, and would be pleased to make the appropriate correction for future editions of the book.